SECRET
LEEDS

John Edwards, David Marsh
& Christopher Allen

AMBERLEY

First published 2017

Amberley Publishing
The Hill, Stroud
Gloucestershire, GL5 4EP

www.amberley-books.com

ISBN 978 1 4456 5512 3 (print)
ISBN 978 1 4456 5513 0 (ebook)

British Library Cataloguing in Publication Data.
A catalogue record for this book is available from the
British Library.

Origination by Amberley Publishing.
Printed in Great Britain.

Contents

About the Authors

John Edwards

John is a retired civil servant living in Pontefract. He writes novels and short stories and is a member of a local writing group based in West Yorkshire. He was born in London, but moved to Yorkshire when his job relocated to Leeds early in 1992 and spent the last eight years of his working life in Leeds, until retiring in 1999.

David Marsh

David Marsh works at the University of Leeds library. In his spare time he writes short stories and articles for magazines. David is currently working on his first novel.

Christopher Allen

Chris Allen works as a government researcher and divides the remainder of his time between writing, running and raising a family. He has lived in Leeds for most of his adult life and has written for the *Fortean Times*, *The Dalesman* and *BBC History Magazine*.

The authors previously collaborated on the successful volume *Leeds: The Postcard Collection*, also available from Amberley.

Acknowledgements

The authors wish to express their thanks to the following people and organisations for their help and support in producing this book:

Richard High, rare books – Special Collections, University of Leeds
Joanne Fitton, Head of Special Collections, University of Leeds
Rhiannon Lawrence-Francis, Collections and Engagement Manager – Special Collections, University of Leeds
Leeds Town Hall
The Middleton Railway
The Discovery Centre

Special photo credits for Chapters 5 and 6 not mentioned in captions (all other images taken by the author or believed out of copyright):

A Speedy Getaway: Photograph provided courtesy of Peter Aveyard.
Gate-crashers: Photograph provided courtesy of Peter Aveyard.
Tasmanian Tiger: Photograph reproduced with permission of Leeds Museums & Galleries.
Gargoyle: Photograph provided courtesy of Ash Allen.
Hippopotamus Bones: Photograph reproduced with permission of Leeds Museums & Galleries.
Church Institute Feature: Photograph provided courtesy of Ash Allen.
Sculpture of Dog: Photograph provided courtesy of Ash Allen.
Carp: Photograph reproduced with permission of Leeds Museums & Galleries.
Pike: Photograph reproduced with permission of Leeds Museums & Galleries.
Butts Court: Photograph provided courtesy of Ash Allen.
Coypu: Photograph reproduced with permission of Leeds Museums & Galleries.
Capybara: Photograph reproduced with permission of Leeds Museums & Galleries.
The Leeds Library: Photograph provided courtesy of Ash Allen.
The City Varieties: Photograph provided courtesy of Ash Allen.

Introduction

One of the Marx Brothers reputedly said, 'There are no secrets in this world except my telephone number and the size of Mae West's underwear.' He was, of course, joking; the joke may be above the heads of the younger generation, but the whole idea of something being secret is that only those privileged to know about it have knowledge it even exists.

In our modern 'open' society there are few secrets to discover. Things that are truly secret remain so and are never revealed. But there are many things hidden from the eyes of the general public, known to a few but not to all – things that time has passed by and the years have caused us to forget – or things that are just not publicised widely and remain unknown to the majority of us.

This book tries to reveal interesting facts about Leeds that are not generally known or have been lost to the modern generation in the mists of time.

The authors expect that some very knowledgeable readers will know some of the matters we have recorded, but hope there is sufficient new material to provide them with new insights about Leeds. We believe that for the general reader much of the book will be a true revelation. Leeds has a remarkable and varied history and culture that deserves to be given wider acknowledgement.

The content of this book aims to be factual, but when discussing ghosts and supernatural phenomenon we are in the realms of speculation and do not necessarily claim that the reports we are giving have been proven beyond doubt and are completely factual.

We hope you enjoy reading this book about the unusual and strange facts that make up the history, heritage and story of the City of Leeds.

John Edwards, David Marsh & Christopher Allen

1. Stories from the Past

Quarry Hill

There are still some people in Leeds who remember the Quarry Hill flats. Housing was a problem in the 1920s, with many slum properties needing replacing. The City's Director of Housing, R. A. Livett, visited France and Vienna to view housing projects there, including the large Karl-Marx-Hof development. He concluded that a large block of flats would provide a solution to the housing problem in Leeds and that the Quarry Hill site would be a suitable location.

Plans were drawn up and building of the flats began in 1935. The construction was of a quick, less-skilled structure of precast fero-concrete cladding mounted on steel frames. The flats were completed around 1938 and designed with many innovative features as an example of the way future social housing might be built. These included lifts, electric lighting, a chute refuse disposal system, communal facilities with shops and laundries

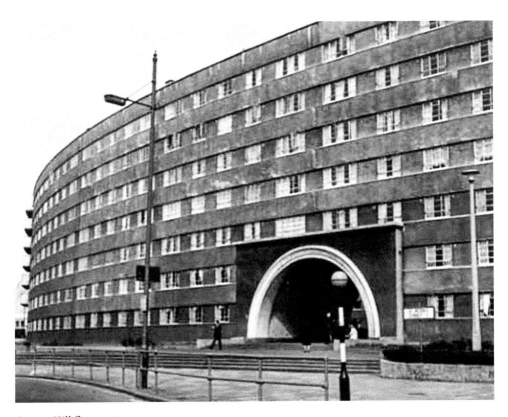

Quarry Hill flats, *c.* 1940.

and solid fuel ranges in the flats. It was the largest such development in Europe when it was built. By 1941 the flats provided accommodation for 3,280 people.

The flats were pulled down between 1975 and 1978, having been poorly maintained and having a limited safe structural future; they had reached the end of their useful life.

Quarry Hill has a long history. Back in the 1600s it was outside the city boundary and plague cabins were built there. The plague was rampant in the city and unfortunate victims of the outbreak were sent there so that they could not spread the disease further. Bubonic plague reappeared in Vicar Lane in 1645. It spread quickly and over 1,300 people died between March and December of that year.

Quarry Hill is also famous for a reputed witch: Mary Bateman, known as 'the Yorkshire Witch'. In 1803, three people living in a draper's shop near St Peter's Square in Quarry Hill were poisoned by her so that she could rob the house and shop once they were dead. She was hanged in York six years later for a similar crime. She had poisoned Rebecca Perigo, a Bramley clothier's wife. Her body was publicly dissected to raise money for the Infirmary and her skeleton is now in the Thackery Medical Museum (see Chapter 3 for the full story of the Yorkshire Witch).

Since the 1990s, Quarry Hill has become the cultural centre of Leeds. It has the West Yorkshire Playhouse, Northern Ballet, Leeds College of Music and BBC Leeds on the site. It is dominated by Quarry House, known by locals as 'The Kremlin'. The building is certainly reminiscent of many old Russian buildings, but the nickname probably reflects more the bureaucratic function of the building. These are government offices housing parts of the Department for Work and Pensions and the Department of Health.

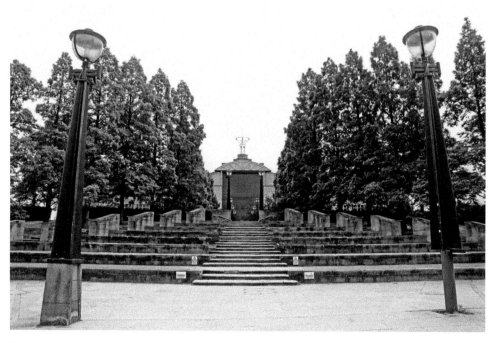

The Quarry House.

There was much speculation when the building was constructed about the flamboyant structure on top of the building. It was rumoured to be a secret government listening and transmitting mast, but the truth is more mundane: it is purely decorative and has no surveillance function. The building is just as innovative as its predecessor on the site. It has a staff social area with a bar and a swimming pool. It also has a resident dentist. These facilities are open to local residents to provide a bridge between them and the government departments occupying the building.

Leeds Minster

Leeds does not have an Anglican cathedral, but does have a Roman Catholic one. For many years St Peter's in Kirkgate has been the Leeds parish church. It was renamed a few years ago as 'The Minster' as being more in keeping with the importance of the main place of Anglican worship for the City of Leeds.

Did You Know?

The famous clothing chain Marks & Spencer had its origins in the city's Kirkgate Market. Michael Marks formed the company when he asked Thomas Spencer whether he would be interested in buying a 50 per cent share of his penny bazaar business. The rest is history.

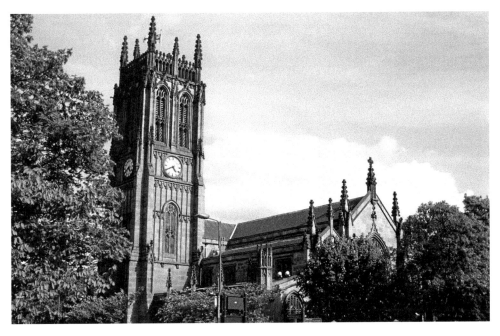

Leeds Minster.

LEEDS PARISH CHURCH.

LEEDS, 25th October, 1841.

At a MEETING of the FRIENDS and SUBSCRIBERS to the RE-BUILDING OF THE CHURCH, held this day at the Music Hall,

THE VICAR IN THE CHAIR,

THE FOLLOWING REPORT WAS PRESENTED BY THE COMMITTEE.

This Church having been duly consecrated by the Lord Bishop of Ripon, on the 2nd of September last, since which time the daily and usual services of the Church have been regularly solemnized therein, the Committee beg to lay before the Subscribers and the Public the following Report:

When the subject of altering and enlarging the Old Parish Church was first agitated (in 1837) it was intended to retain the whole of the external works, (putting new tracery into the windows,) to remove the Tower from the centre to the North Aisle, to extend the two lines of the columns in the Chancel so as to give a breadth equal to that of the nave, and to raise the roof of the North Aisle; but on a re-inspection of the Church, the materials of the old walls and the roofs, and other wood work, were found to be much more unsound than was at first imagined, and as the works progressed and the wood casings round the stone work were removed, the greater part of the building, together with the foundations appeared to be in a very dangerous state. This was especially the case with the Tower, two of the piers supporting it being overweighted and cracked from top to bottom, and placed on a foundation of loose stones and rubbish a little below the surface, so that the Tower could not be insured from day to day.

From these circumstances the Committee were placed under the necessity of obtaining fresh designs and new estimates; and at a Public Meeting held on 27th November, 1839, they made a

Leeds parish church's rebuilding report.

The first church on the site of the parish church was built of timber around AD 655, but was destroyed by fire at an unknown date. A stone church was then built with a simple Saxon nave and small chancel. It was extended after the Norman invasion, but another fire during the reign of Edward III required yet another reconstruction. This time the church had a choir, transepts and a large central tower. In 1714, an organ was introduced, and John Wesley visited three times between 1743 and 1799.

In the 1830s a new vicar, Dr Walter Farquhar Hook, decided that the state of the medieval church did not provide for the needs of his congregation. He commissioned designs for a new church from the architect R. Dennis Chantrell, which was completed by 1841 in the eighteenth-century Romantic style.

Illustrated above is a printed report, dated 20 October 1841, recording a meeting of the 'Friends and Subscribers to the Re-Building of the [Leeds Parish] Church' held on 25 October 1841 at the music hall.

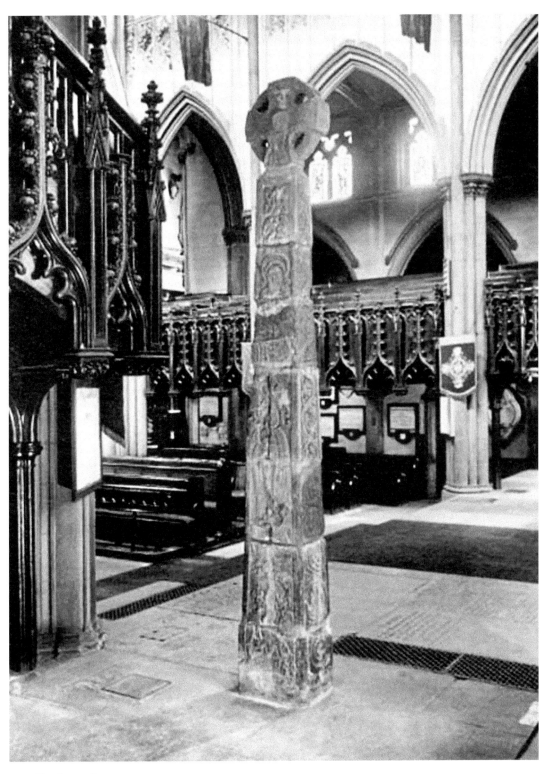

The Saxon Cross.

The report occupies three pages and it mentions the consecration of the church by the Lord Bishop of Ripon on 2 September 1841. It includes the architect's report describing the works carried out to provide additional space for the congregation and financial details of the building work. The original estimate for the works of £19,658 was exceeded and the revised estimate was £26,000, leaving a further sum of £6,000 needing to be raised.

The vicar of the church, Revd Walter Farquhar Hook, supervised the rebuilding and was later buried in the church.

Several memorials and monuments from the old church were kept. New fittings included Gothic galleries, a particularly high pulpit and an elevated altar. Since the day it was consecrated, the only main alteration has been to the sanctuary in the 1870s.

The city's oldest historical monument stands in the chancel; a partly remodelled Saxon memorial cross, discovered when the old parish church was demolished in 1838.

Leeds Minster
St Peters House, Kirkgate, Leeds, LS2 7DJ
Tel: 0113 245 2036
Website: http://www.leedsminster.org

The First Moving Pictures

Just south of Leeds Minster is Crown Point Bridge, where the first moving pictures were filmed (read more about this in Chapter 3). You can see the actual film on the Leodis website at: http://www.leodis.net

On the other side of the bridge are several places of interest to explore.

Tetley's Brewery

Just over the bridge, on the other side of the River Aire, is the site of Tetley's Brewery, founded in 1822 by Joshua Tetley. The brewery itself is no longer there. Tetley's was taken over by Carlsberg in 1998. For a time there was a popular visitor centre but that has now gone. Sadly the big Tetley dray horses have also gone; they were a frequent sight around Leeds, delivering Tetley beer to the various public houses that sold it.

In 2008 the brewery's closure was announced. A Carlsberg spokesman said, 'It is an old brewery and the one in Northampton is bigger and more modern.' In December 2010, production of Tetley's cask products was transferred to Banks's brewery in Wolverhampton. The final brew took place on 22 February 2011 and lager production was transferred to Northampton. Despite protests from beer drinkers that Tetley's Cask brewed in Wolverhampton would taste different, care is taken to produce the beer in the traditional way and Tetley's beer continues to be a popular choice by many drinkers, proving that Leeds knows how to brew a good pint of beer!

Tetley's headquarters building has become the home to contemporary art and learning and represents an interesting mix of old and new, where heritage is preserved yet reinterpreted, helping us make sense of our past while pointing to possible futures for this historic site, the City of Leeds and its public. Refurbishment of the building is supported by Carlsberg UK, who have worked with Chetwoods Architects and Arup to redevelop the headquarters into a usable publicly accessible building.

From Printworks to College Campus

Passing the site of Tetley's Brewery, we are faced with the old printworks on Hunslet Road, recently taken over as a campus by the Leeds City College, with the interior of the building extensively redesigned to suit the new usage. A restaurant and a hairdressing salon on the campus appeal to many Leeds residents; they provide services for the public as a means of training the students at prices that reflect the fact that those providing the service are still learning their trade.

Alf Cooke, born near Dewsbury Road in 1842, opened his first business on Hunslet Road in 1866, selling stationery and newspapers and doing letterpress printing. He first established a printing works on Hunslet Road in the 1870s, which was destroyed by fire in 1880. He then started a second printing business but this was also destroyed by fire on 30 September 1894. Alf then built a new factory, which was designed by Thomas Ambler and had a turret clock, imitating the Leeds town hall. It is now a Grade II-listed building.

Alfred Cooke became Lord Mayor of Leeds in 1890 and lived at Weetwood Hall. This later became the property of the University of Leeds as a hall of residence for women.

The Printworks.

The Discovery Centre

A little way east of the printworks in Carlisle Road is the Leeds Discovery Centre. This is the depository for the most amazing collection of items in Leeds. There are too many to show in the Leeds museums and this is where the extra items are stored. You need to see it to believe it! Literally thousands of exhibits from art works to zoological specimens; from a stuffed albatross to a full-sized zebra. There are costumes, early typewriters, old furniture and old artefacts of every description. The exhibits are carefully stored in a gigantic room, which is a controlled environment to ensure that the exhibits do not deteriorate. Admission is free, but if you want to join a guided tour you will need to book in advance.

The centre also runs a series of workshops on a variety of subjects, such as African and Asian Masks, the Plains Indians, Magical Mini Beasts, and much more. It aims to be a resource for all ages to learn about the past and for researchers to hunt down the information they are seeking.

If you intend to visit you will need to phone ahead to book a time. There are guided tours at certain times that you can join.

Leeds Discovery Centre
Carlisle Road, Leeds, LS10 1LB
Tel: 0113 378 2100

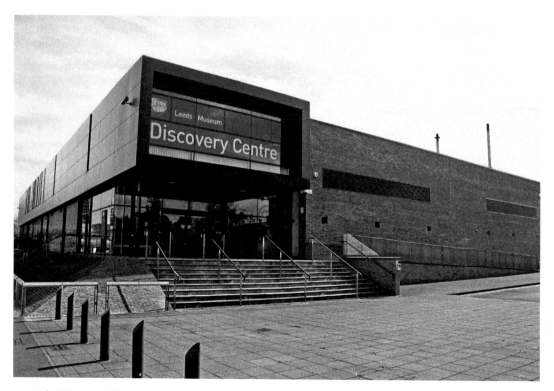

The Discovery Centre.

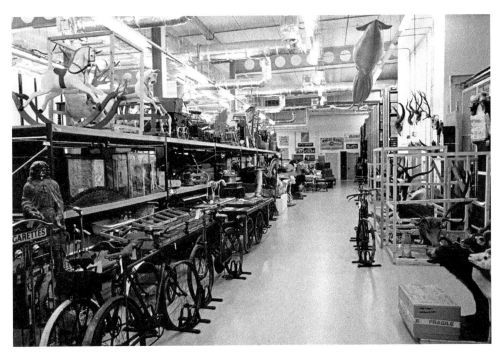

Inside the Discovery Centre (Photograph reproduced with permission of Leeds Museums and Galleries).

The Oldest Working Railway in the World

Just south of the Leeds Discovery Centre in Hunslet is the Middleton Railway. Known to the locals and railway preservation enthusiasts but largely unknown to the rest of Leeds, it really deserves a more prominent place in railway history. It is the oldest working railway in the world.

The Middleton Railway is now run by a group of volunteer enthusiasts. A wagonway was originally built in 1757 to transport coal from the Middleton pits to Leeds. They were in competition with a pit in Rothwell that used the river to transport its coal and Middleton's wagonway enabled them to compete on equal terms. The owner was Charles Brandling, who made railway history by ensuring an Act of Parliament in 1758 guaranteed the route was permanently protected. This was the first Act passed for building a railway. The wagonway was opened in September 1758, and thousands of tons of coal each year were hauled by horses along it. This helped the commercial development of Leeds: the price of coal dropped and Leeds became an attractive place for industries that relied on coal to power their activity, such as glass and pottery manufacture and cloth making.

By 1812 the Middleton colliery was again finding it difficult to operate. The horses used to pull the wagons were being bought by the army to pursue the war against Napoleon. The colliery steward, John Blenkinsop, introduced steam engines to pull the wagons on rails. Mathew Murray designed and built four locomotives for the line – the first ever commercially viable locomotives in the world. They were also the first railway to employ a regular train driver – James Hewitt. He was trained by Fenton, Murray & Wood, the

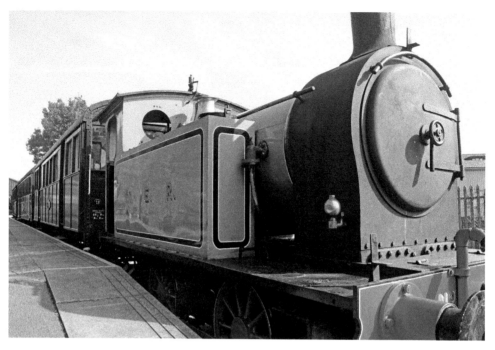

A train about to depart from Moor Road Station.

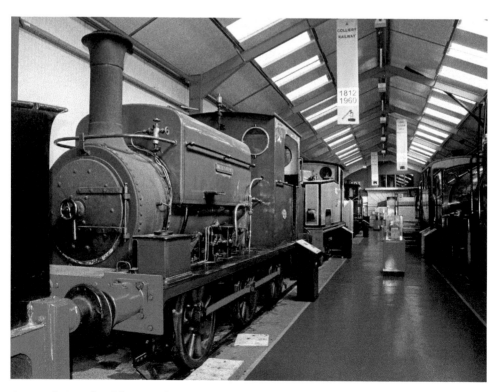

A general view of Middleton Railway Museum.

A manufacturer's plate.

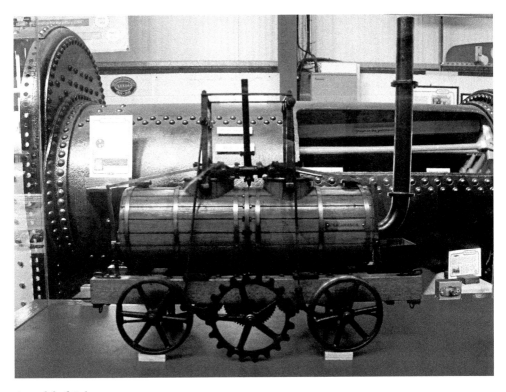

A model of *Salamanca*.

company that built the locomotives. The railway was not without accidents. For example, in 1818 a boiler exploded, killing the driver. A similar accident occurred in 1834, probably due to the boiler being in poor condition. Again the driver was killed – none other than James Hewitt, their first driver.

Steam engines began to be used worldwide and Leeds had a number of engineers experienced in the design and construction of steam engines. Hunslet therefore became a centre for the building of locomotives, which were exported around the world. In 1881 the Middleton Railway switched its track to the standard gauge, allowing it to connect with the Midland Railway.

In 1947 the colliery become part of the National Coal Board, which led to changes and the closing of parts of the line. Clayton, Son & Co., the owners of a section of abandoned line, allowed a group of railway preservation enthusiasts from the University of Leeds to take over their section, comprising of around 1 mile between Middleton Park and Hunslet. The founder of the group was Dr R. F. Youell, a lecturer at the university. The group has continued to operate the line at weekends and bank holidays for train enthusiasts and families wanting a day out. But how many passengers on the line realise it has a very old and turbulent history?

There is a museum at the Moor Road station with several steam locomotives to delight enthusiasts. Not so well known is the fact that at one time Leeds was a leader in the design and manufacture of steam locomotives and many are on show at the museum together with interesting artefacts relating to the history of the steam locomotive. The first successful steam locomotive was *Salamanca*. It was built in 1812 and hauled eight loaded coal wagons from collieries at Middleton to Hunslet Moor. It was designed by John Blenkinsop and built by Fenton, Murray & Wood at the Round Foundry in nearby Holbeck. It had a unique middle wheel designed to aid traction, as can be seen in the picture of a model on view at the museum.

Middleton Railway
Moor Road, Leeds, LS10 2JQ
Tel: 0113 271 0320
Website: www.middletonrailway.org.uk

Kirkstall Abbey and Abbey House Museum

Moving to North Leeds, a major visitor attraction is Kirkstall Abbey. It was one of the victims of the Dissolution of the Monasteries during the reign of Henry VIII. It was founded by a group of Cistercian monks, headed by Abbot Alexandra, in 1152 with support from the Norman nobleman Henry de Lacy to acquire the land. The building work was completed in around 1182. For several centuries the abbey thrived and became one of the most important and wealthy in the North of England. However, Henry VIII needed money to finance and maintain his kingship and saw the monasteries as an easy and lucrative source of income. Kirkstall Abbey was disestablished, and the Crown became a little richer. In modern times the ruins have been preserved and a visitor centre now welcomes tourists. There is also a museum and, of course, a souvenir shop.

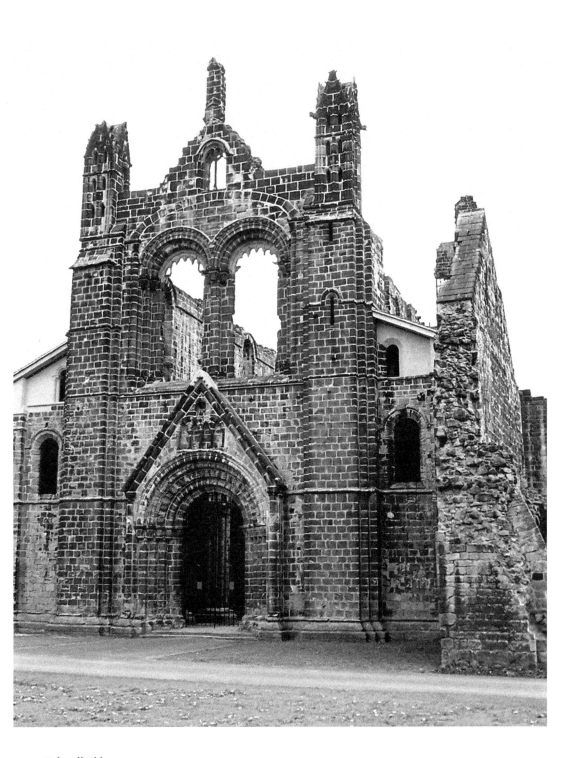

Kirkstall Abbey.

There is a car park across the road from the abbey, which after leaving you will see a most remarkable building in front of you – the Abbey House. This is well worth a visit while you are in the area. It contains a complete street of Victorian shops and businesses. You can even get dressed up in a Victorian costume if you wish. The shops are as authentic as Leeds City Council, who owns the museum, can make them. It is a truly fascinating insight into the way that Victorians lived.

Did You Know?
Each year over 10 million people visit Leeds from both the UK and overseas, contributing in excess of £700 million to the local economy.

Abbey House, *c.* 1910 (from an old postcard).

2. Hidden Treasures of Leeds

The Brotherton Library, University of Leeds

Anyone taking a stroll to the summit of Woodhouse Lane surely couldn't fail to notice the stately and somewhat imposing Parkinson Building. One of the most famous landmarks of Leeds, this Grade II-listed edifice forms the entryway into the Brotherton Library, the Stanley & Audrey Burton Gallery and the newly opened Treasures Gallery, showpiece of the world-renowned Special Collections, which hosts fascinating items of both literature and art.

Special Collections has over 200,000 rare books in its keep, as well as thousands of important manuscripts. Five of the collections held there have been awarded 'Designated' status by the Arts Council of England in recognition of their importance, a fact that, at the time of writing, no other institution can boast. These celebrated collections comprise the English Literature Collection, Romany Collection, Liddle Collection, the Leeds Russian Archive, and the Cookery Collection. We shall look closer at some of the works held in these later.

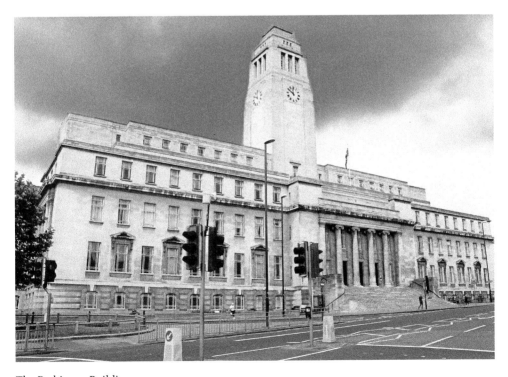

The Parkinson Building.

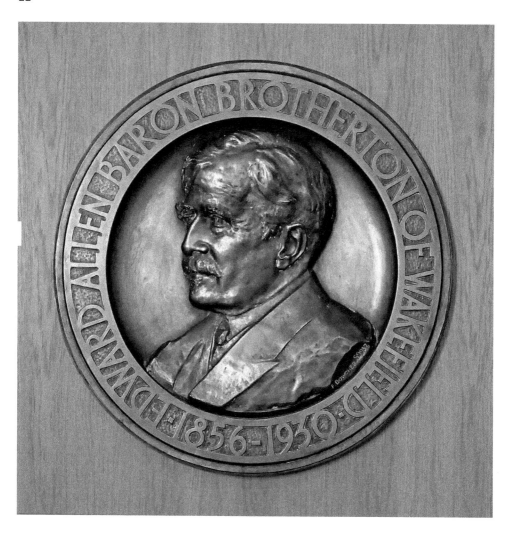

The commemorative plaque of Lord Brotherton, benefactor of the university library outside the Treasures Gallery (with kind permission from Leeds University Library).

Special Collections is an extension of the original Brotherton Collection, a substantial compendia having being donated to the library by Edward Allen Brotherton (1856–1930). Brotherton was a major benefactor of the university, donating £100,000 to the building of the library, which was subsequently named after him. Brotherton himself laid the foundation stone of the library in June 1930, a mere four months before his death. It was at this point that Brotherton announced his intention to donate his considerable collection of literature to them, to be held 'in trust of the nation'.

Edward Brotherton, born in Ardwick, Manchester, had amassed a personal fortune by building a successful chemical empire, which became the largest of its kind in Britain. He moved to Wakefield when he was twenty-two, establishing his first chemical plant there.

He later expanded his works and built further factories at Leeds, Liverpool, Birmingham, Sunderland and Glasgow.

At the age of twenty-six, Brotherton married Mary Jane Brookes but the marriage was tragically short lived as Mary died giving birth to their first child. The child itself did not survive long and the heartbroken Brotherton never remarried, instead preferring to concentrate his energies into building his business empire. Brotherton did however become close to his niece-in-law, Dorothy, who had married Charles Ratcliffe, heir to Brotherton's chemical fortune. Dorothy was later to become famous in her own right, writing poems and plays under her full name of Dorothy Una Ratcliffe, or D. U. R as she was affectionately known. Due to Charles' philandering tendencies, her marriage was hardly idyllic; however, the two did not divorce as this would have complicated her uncle's political aspirations at the time.

Edward Brotherton became mayor in 1913, aided and abetted by his ever-supportive niece-in-law. It was Dorothy's suggestion that the pair start collecting books and manuscripts, which would later become known as the Brotherton Collection.

Brotherton's first foray into the world of auctions was somewhat faltering. He had been keen to purchase the Towneley Manuscripts, a series of thirty-two mystery plays with a biblical theme (also known as the Wakefield Mystery Plays) but, being somewhat new to the ways of auctioneering, lost out to another bidder. He did however manage to secure a copy of Andrew Marvell's *Miscellaneous Poems* (1681), which softened the blow. Ever watchful and keen to learn, the pair soon began to add to their collection, securing many fine works of both literature and art, including four seventeenth-century Shakespeare folios and texts by the Brontës, which contained, among many literary gems, letters exchanged between Branwell and Charlotte, as well as a first edition of *Jane Eyre*. Much of the collection was stored in specially designated rooms within the library, the most beautiful of which is undoubtedly the main room on the upper floor, known unsurprisingly as the Brotherton Room. This charming room is often used to display selections from Brotherton's vast literary treasures. However, the cream of Brotherton's collection is now displayed in the new Treasures Gallery within the Parkinson Court, the centrepiece of which is undoubtedly Shakespeare's *First Folio*.

The *First Folio* was published in 1623, seven years after Shakespeare's death. It contains eighteen previously unpublished plays, including such notable works as *Antony and Cleopatra*, *The Tempest* and *Macbeth*. Some of Shakespeare's other works had been published earlier in the smaller quarto format and are included in the *First Folio* in a somewhat different arrangement from the quarto versions. Some plays appear to have been edited and modified, either missing previously published text or having had text added to them. The *First Folio*, although being the most collectable and important publication, is not the rarest edition of Shakespeare's collated work. That honour belongs to the *Third Folio*, mainly due to the fact that most reserve copies were destroyed in the Great Fire of London in the autumn of 1666.

The *First Folio* held in the collection was originally bound in a rather lacklustre calf shell but it was rebound by Francis Bedford (1799–1883) in a brilliant red goatskin jacket and decorated along the edges with a gold floriated design. Bedford was one of the most skilful bookbinders of his age and it is a testament to his restorative expertise that the

The Brotherton Room (with kind permission from Leeds University Library).

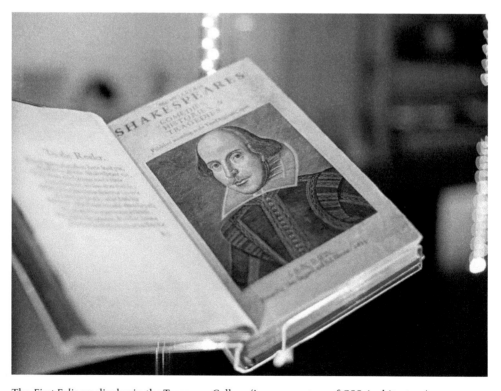

The *First Folio* on display in the Treasures Gallery (image courtesy of GSS Architecture).

folio looks in such good condition today. Whether or not Brotherton employed Bedford to rebind the folio is unclear. The *First Folio* came to the library in 1936 and has since been digitalised for the modern era.

The English Literature Collection

Shakespeare is not the only luminary to be represented within the Special Collections archive. The library has in its possession works and letters written by J. R. R Tolkien (1892–1973) the famous author of *The Hobbit* and *The Lord of the Rings*. Tolkien was a lecturer at the University of Leeds during the 1920s. During his tenure, he worked in collaboration with fellow lecturer Eric Valentine Gordon (1896–1938) to produce what is regarded as the definitive version of *Sir Gawain and the Green Knight*. Tolkien also contributed a supplement to Kenneth Sisam's fourteenth-century verse and prose entitled *A Middle English Vocabulary*, which was a glossary to the work. Sisam was Tolkien's former tutor in English Language and English Literature. Tolkien's glossary didn't appear in the original publication of Sisam's work, but it did appear in later editions. *A Middle English Vocabulary* has since been published as a separate volume in its own right and is regarded as Tolkien's first published book.

Tolkien and Gordon also formed The Viking Club while at Leeds. This quaint gathering gave members the opportunity to perform songs and poems they had written in both Old English and Old Norse. These manuscripts, which include the rare *Songs for the Philologists*, form part of the Tolkien Collection, alongside letters penned by Tolkien to Gordon's wife, Ida, and a first edition of *The Hobbit*, which Tolkien dedicated to the Gordon family. Tolkien penned a series of poems to both Eric and Ida – one from June 1935 was written on examination paper – giving thanks to the couple for their kindness and hospitality in his regard.

Tolkien published around nine poems while at Leeds, which appeared in specialist magazines with a somewhat limited circulation, one of which was penned anonymously. In 1925, Tolkien unexpectedly resigned his position at Leeds as he had been successfully elected to the Rawlinson and Bosworth professorship at Oxford, a post he was to hold for twenty years.

Delving further into the English Literature collection, we discover further gems. Special Collections has a sizeable assortment of Brontëana, which not only includes first edition works of the Brontë sisters but also rare poems and letters. Some of the most fascinating manuscripts include exercise books that feature Charlotte's elegant handwriting. These date from her time in Brussels during the early 1840s at the Pensionnat Heger School for young ladies.

The scripts of these books show examples of Charlotte's early attempts to learn French as well as a draft in French of *L'Immensité de Dieu*, which translates as 'The Immensity of God'. This piece was written for her tutor Constantin Heger, a man who had a significant influence on Charlotte. Charlotte was besotted with Hager to such an extent that when she eventually left Brussels in 1844, she wrote to him every fortnight. It was only on the censure of Hager's wife that Charlotte finally stopped her correspondence.

Also represented within the Brontë collection is Charlotte's acquaintance with Elizabeth Gaskell (1810–65). Gaskell, a novelist famous for penning such works as *Mary Barton*,

North and South, *Sylvia's Lovers*, and *Cranford*, was to become Charlotte's biographer. Gaskell's book, *The Life of Charlotte Brontë*, was published by Smith, Elder & Co. in 1857. Again, in graceful script, Charlotte pays homage to Gaskell describing her as a 'woman of many fine qualities'.

The three sisters and their significant contribution to the literary world have become immortalised, but we should not ignore their troubled brother Branwell (1817–48). Special Collections has within its possession letters, poems and drawings penned by Branwell, including the fascinating series of miniature books based on the fictional world of Angria that he created with Charlotte. These date from 1834 and were inspired by early games at the siblings played, which featured toy soldiers.

Branwell was also an accomplished portrait artist. His art often reflected his state of mind: he moved from standard portraiture to invoking haunting images of tombstones, death and chained men as he descended into an abyss of black moods and depression, fuelled by chronic alcohol and drug addiction. One of the most striking images held within the Brontë Collection is an ink drawing entitled *Our Lady of Grief*, which depicts a sorrowful woman stood on top of a raised platform on an isolated hill, head bowed and tilted towards a tombstone by her feet.

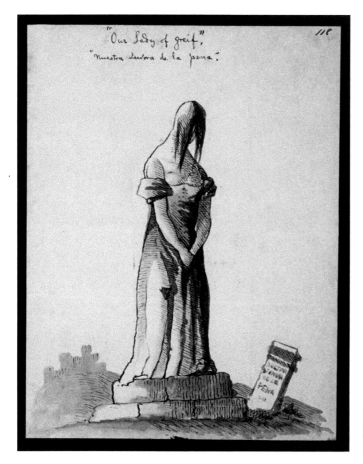

Our Lady of Grief (with kind permission from Leeds University Library).

Of further interest are collections of letters that Branwell wrote to Joseph Bentley Leyland (1811–51), a fellow artist who, like Branwell, suffered from various debilitating addictions. Leyland has often been blamed for leading Branwell astray, however it is more likely that the pair were drawn together through their addictions as much as their art. The letters date from 1842–48 and follow Branwell in a series of personal disasters, both professionally (being dismissed as a tutor from the Robinson family – a sure embarrassment to his sister Anne, who was a governess with them) and personally, where his waning mental and physical health is all too apparent. These letters of correspondence form a tragic epistle in the life of a complex and fascinating character.

Other Yorkshire authors are also well represented. A collection of works by Bingley author John Braine (1922–86) includes signed and draft copies of some of his novels, including *These Golden Days, Man at the Top* and *The Only Game in Town*. The Braine collection also includes twenty-five autographed poems dating from 1943–48 as well as numerous journalistic articles and diaries.

Braine emerged in the 1950s and was part of the collective 'angry young men', a group of authors who specialised in writing gritty, hard-hitting dramas that focused on the social issues of the working class. Braine's first novel, *Room at the Top* (1957), was turned into a successful film starring Lawrence Harvey and Simone Signoret.

Another fully paid-up member of the 'angry young men' club, Stan Barstow (1928–2011), is also represented within the collection. The Wakefield-born author, with twelve novels to his name, is perhaps most famous for his novel *A Kind of Loving* (1960), an autographed draft of which is held alongside others, including *A Raging Calm and A Brother's Tale*. Letters and correspondence with fans of his work give a rare insight into the personality of an often very private man.

There is so much within the English Literature collection to be enjoyed by the visitor to the library that an entire book devoted to this one collection alone could easily be written, as could be said of the other collections, which we shall now turn to.

The Romany Collection

The Romany Collection was awarded Designated status in 2005. The collection of poetry, art and verse was presented to the university in 1950 by the aforementioned Dorothy Una Ratcliffe, who had developed a strong appetite for Romany culture. Dorothy was convinced that she had gypsy blood in her veins, which enabled her to wax lyrical in the many poems and ballads that she penned, evoking the spirit of the traveller. Some of these works appeared in the *Dalesman* magazine to which she was a regular contributor. Dorothy's collection of gypsy-related writing includes the experiences of author George Borrow (1803–81).

Borrow penned numerous novels based on his personal experiences with Romany travellers both at home and on the Continent, perhaps the most famous being *Lavengro* (1851) and its sequel *The Romany Rye* (1857). These semi-autobiographical works of fiction were not greatly appreciated in Borrow's lifetime, however, as is often the case, the works found a new respect with the passage of time and have since become regarded as classics. Early autographed drafts of these works are held within the library.

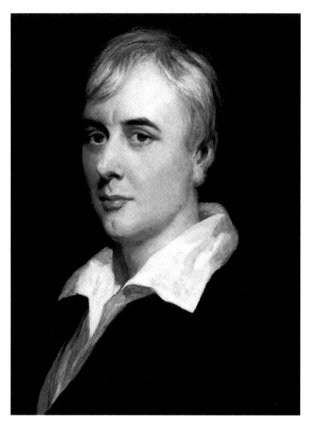

George Borrow.

Rarer texts within the collection include those of Russian and Moravian origin, and exquisite works of verse, particularly Raymond Muncey's *Our Old English Fairs*, Margaret Fletcher's *Sketches of Life and Character in Hungary*, and Edwin Flood's song 'The Gypsy's Life is a Joyous Life'.

In 2002, the library acquired Sir Angus Fraser's (1928–2001) considerable archive of gypsy material. Fraser, a native of Dumfries, was a former permanent secretary and high-ranking civil servant who, like Dorothy Ratcliffe, held a fascination for gypsies. Fraser was president of the George Burrow Society and was regarded as the leading authority on his works. In 1992 Fraser published his seminal work, *The Gypsies*, to high acclaim. This ever-expanding collection is well worth researching as it gives a unique insight into a culture that is little understood in today's high-tech, fast-paced world.

The Liddle Collection

The Liddle Collection comprises of items relating to the two world wars, collected by historian and former lecturer Dr Peter Liddle. Liddle, president of the Second World War Experience in Wetherby, has long held a fascination for the personal experiences of individuals who lived throughout the wars and began a private collection of material, which included unpublished diaries, manuscripts, correspondence and letters showing the human side of war.

The collection was started in the 1970s and features items from Germany, Belgium, France and the commonwealth countries. The collection, donated to the university in 1988, is not restricted to the experiences of service personnel. Accounts are available to view from those involved with life on the home front, whether as civilians, working with the emergency services, or involved within the resistance movement. There is a significant amount of material that relates to conscientious objectors, and a number of letters have been on display in the Treasures Gallery, giving examples of pleas by individuals to be exempted from military service. In contrast, there are other manuscripts in the collection showing the contempt in which many in society held conscientious objectors, particularly during the First World War. Government papers that formed part of the exhibition within the gallery showed the historical context of pacifist movements of the time, as well as the options available to those who refused the call to arms.

There are over 4,000 personal manuscripts from people who lived throughout the First World War within the Liddle Collection, and around 500 from those who experienced the horrors of the Second World War.

It is not only the written word that features in the collection. Items such as bereavement plaques, gas masks, medals, propaganda posters, badges, gift boxes, photographs and artwork are among the highlights. There are some objects within the collection that date back as far as the Boer Wars (1800–01 and 1899–1902), namely a bush hat and a ration tin. Some of these items are stored off-site but arrangements can be made for their viewing upon request.

Did You Know?

The oldest flying aeroplane, the Blackburn Type D, was constructed in Leeds. Built in 1912 by Robert Blackburn (1885–1955), the monoplane now forms part of the Shuttleworth Collection in Bedfordshire. It was here that the plane was carefully restored and made airworthy once again. The plane was originally built for the renowned aviator Cyril Foggin (1891–1918), who flew for the RFC during the First World War. Foggin was an ace pilot who quickly reached the rank of Major before he was killed in a car accident in France, not far from the Western Front.

The Leeds Russian Archive

The Leeds Russian Archive was awarded Designation status in 2005 and features over 500 separate collections of documentation, including photographs and texts exchanged between Britain and Russia throughout the nineteenth and twentieth centuries. Some of the journals and papers give an absorbing insight into the lives of the British populace living in Russia at the time, as well as those of diplomats, travellers and military personnel.

The collection also catalogues the history of Russian nationals forced to flee their native land for social and political reasons, notably the revolution in the early 1900s and the subsequent formation of the USSR.

Of worthy note are the manuscripts belonging to the distinguished railway engineer Yuri Lomonosov (1876–1952). Lomonosov designed the world's first fully productive mainline diesel-electric locomotive, the E el-2, which came into service in 1925. He also developed the theory of traction locomotives and formed the first research faculty devoted to locomotives.

Lomonosov's work took him across Europe and eventually to the United States, where he worked as a representative for the Ministry of Railways on behalf of the Russian Provisional Government. Lomonosov settled for a time in Berlin (1924–25), where he worked as a teacher and consultant. He had no wish to return home to Russia, so with his second wife Raisa moved to Britain in 1938, eventually taking up British Citizenship. In 1952 Lomonosov relocated to Canada via the United States, where he fell ill and died shortly afterwards.

Literary manuscripts of notable Russian writers are also held within this collection. Of particular interest are the personal correspondence and documents of the playwright Leonid Andreev (1870–1919). Born in Oryol, some 220 miles from Moscow, Andreev developed a keen interest in literature from a young age and as he matured particularly enjoyed the philosophical works of Nietzsche. Although Andreev trained as a lawyer, his heart was with the written word; in 1902 he became the literary editor of *Courier*, where, among other notable writers of the time, he published the works of Chulkov and Remizov. At this time, Andreev himself was becoming a successful writer, producing stories such as *The Abyss* and *In The Fog* to high acclaim. At the time of Russia's war with Japan (1904–05), he published a novel entitled *Red Laughter*, which exposed his disgust at the senseless waste of war. By 1908, Andreev had written a number of plays, his first entitled *To the Stars*. Eventually, his writing became so highly regarded that Constantin Stanislavsky (1863–1938) and Vsevelod Meyerhold (1874–1940) produced his works in Moscow and St Petersburg respectively to great approval.

Andreev was also a talented artist and some of his work was displayed in St Petersburg, drawing praise from the realist painter Ilya Repin (1844–1940) and also from the painter and philosopher Nicholas Roerich (1874–1947).

The first Russian to win the coveted Nobel Prize in Literature, Ivan Bunin (1870–1953) also features within this remarkable collection. With special permission, the visitor to Special Collections can view Bunin's manuscripts, personal correspondence and illustrative work.

Bunin was an accomplished poet and novelist, perhaps best known for his novellas *The Village* (1910) and *Dry Valley* (1912). It was the former of these two books that elevated Bunin to star status in his homeland. Such was the gritty realism of the work, depicting country labourers of low intelligence and their tendency to violence, that Maxim Gorky (1868–1936) another revered author, was moved to suggest that Bunin was the best Russian writer of his time. Bunin was a close friend of Anton Chekov (1860–1904) of whom his work was often compared due to its sense of realism and witty observances of character.

The Cookery Collection

The final collection, awarded Designation status in 2005, is the Cookery Collection. This expansive compendium was given to the library in 1939 by Blanche Leigh, Lady Mayoress

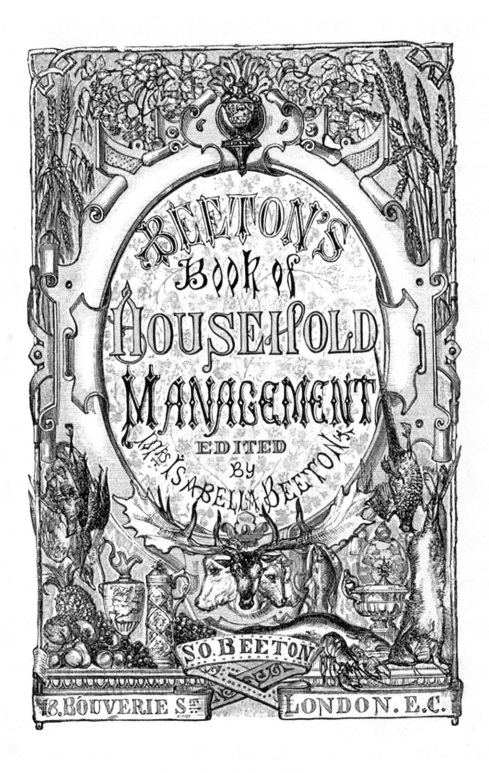

BEETON'S
Book of
HOUSEHOLD
MANAGEMENT
EDITED
BY
MRS ISABELLA BEETON

S. O. BEETON

18. BOUVERIE ST. LONDON. E.C.

The title page from the original *Beeton's Book of Household Management*.

of Leeds, and comprises of British, French and Italian books and manuscripts dating from the late 1400s through to the 1930s.

The Cookery Collection has continually expanded and includes the Camden Library cookery collection, which contains over 100 rare Chinese books that feature subjects such as vegetarianism and medicines.

Closer to home, the collection boasts four first editions of the classic *Beeton's Book of Household Management* (1861), which can be consulted in the Special Collections reading room. Isabella Mayton (1836–65) was born in London, married publisher Samuel Beeton and very quickly began to contribute cookery and domestic-related articles for one of her husband's publications, *The English Woman's Domestic Magazine*. These articles were eventually collated into a single volume, *Beeton's Book of Household Management*, which sold approximately 60,000 copies within its first year. To this day the book continues to be a popular purchase.

Special Collections also has in its possession a second edition of *The Accomplisht Cook* (1660) by Robert May (1588–1664), a cook who had been in the service of high-ranking Catholic families. May chronicles a bizarre narrative on how to incorporate 'performing' dishes at festive occasions. One such recipe suggests having live birds appearing from a pie once the lid has been removed, and another that produces wine that 'flows as blood running out of a wound'. One recipe has frogs emerging from a pie, which, apparently, was supposed to delight and impress the ladies.

Also of interest, and no less impressive, is a recipe dating back to the fifteenth century, 'Stewet Beef to Pottage', which was published in 1790 by the Society of Antiquaries. This recipe comprised of copious amounts of wine, beef, onion, cinnamon and mace. The pottage eventually became a favourite Christmas dish that apparently was something of an acquired taste.

There are other interesting books and recipes available to view that date back to the seventeenth and eighteenth centuries. There is a handwritten manual that contains fifty-four recipes and details the mass production of cordials, one of the most bizarre being instructions on how to make a drink using wormwood.

With literally thousands of books, manuscripts and artifacts, and a host of other exclusive collections besides those focused on in this section, the visitor to Leeds will find an investigation of Special Collections and its associated galleries a veritable Aladdin's cave of secrets and treasures.

3. People and Places

Pablo Fanque

The visitor to St George's Fields cemetery, now part of the University of Leeds campus, might be intrigued to find the grave of Pablo Fanque (1796–1871). Born William Darby, Pablo was the first black British circus owner and became the inspiration of the Beatles song 'Being For The Benefit of Mr. Kite!' from their acclaimed *Sgt. Pepper's Lonely Hearts Club Band* album of 1967. Fanque's circus was regarded by many as being the best of the Victorian era, attracting crowds in excess of 600 at its peak. Pablo himself performed in the circus, his particular skill demonstrating complex equestrian tricks and dances on his

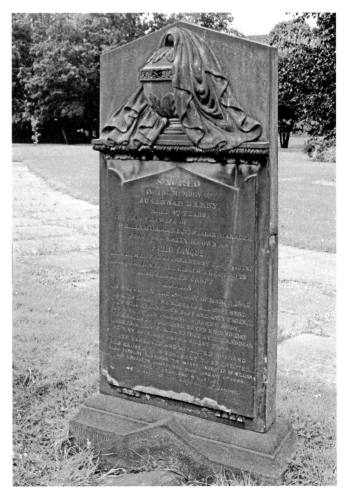

Three images showing the graves of Pablo Fanque and his first wife Susannah.

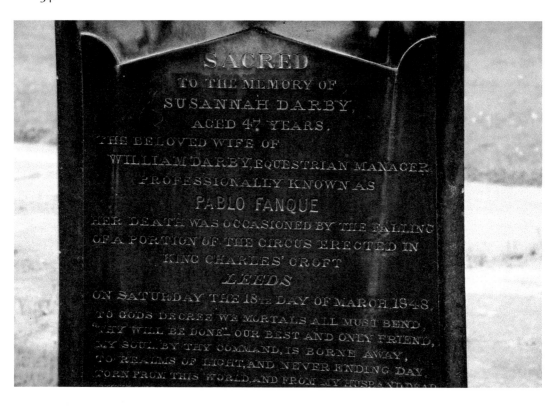

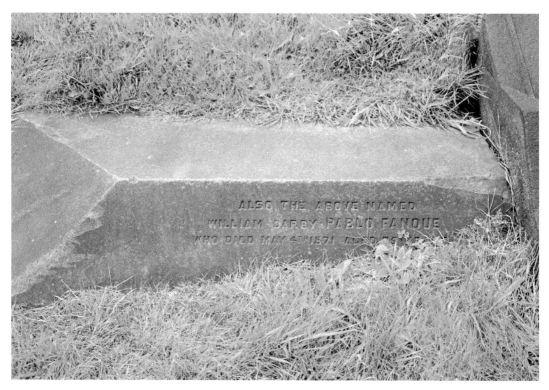

trusty black steeds Beda and Henry, delighting audiences nationwide.

At a time when slavery had only recently been abolished in Britain, the viewing public warmed heartily to Pablo, who also drew much praise from the press. Pablo was a compassionate man who belonged to a Masonic-like organisation known as the Ancient Shepherds, who specialised in helping impoverished families meet funeral expenses.

Fanque married Susannah Marlow and had two sons who went on to become circus performers themselves. The marriage ended tragically, however, while one of the sons, Lionel, was performing a tightrope act at the Amphitheatre at King Charles Croft on the Headrow. The wooden viewing gallery collapsed under the weight of hundreds of spectators. Although casualties were quite light, Susannah, who had been watching her son perform, was hit on the head by several heavy wooden beams as the structure fell and she died at the scene. Susannah is also buried in St George's Field cemetery. Pablo Fanque died of bronchitis on 4 May 1871 at the Britannia Inn, Stockport. He is buried next to Susannah, his first wife.

Rebecca Stockdale

The reader might not necessarily be familiar with the name of Rebecca Stockdale (1760 –1807) but this lady cuts a particularly tragic figure in the history of Leeds. The daughter of a local stonemason, Rebecca was a victim of the notorious Mary Bateman, 'The Yorkshire Witch', and played a significant part in Bateman's eventual downfall.

Rebecca married Bramley clothier William Perigo, a man of little means, and the couple lived happily together for nineteen years, despite the scarcity of money. However, in 1806, Rebecca's mental health began to suffer. The woman believed that she was under the possession of an evil spirit, and it was from this point on that she and her husband fell under the spell of a 'very real evil'. A well-meaning friend suggested to Rebecca that she pay a visit to Mary Bateman (née Harker), a woman who had earned herself a reputation for being able to ward off malevolent spirits as well as work miracles and predict future events. Mary was a feared yet respected woman and would certainly be able to help Rebecca with her malady. Unbeknown to the ill-fated Rebecca, Mary was a murderer and serial fraudster. Bateman's particular trademark was in the brewing of poisons, a skill she probably learned from local gypsies, with whom she was friendly as a child. Mary had already murdered her mother and two sisters having persuaded them to partake of one of her evil concoctions. She got away with her act of felony, despite the doubts of a local doctor, by saying her family had succumbed to a plague.

As the ill Rebecca had taken to her bed, it was her husband William who made the initial visit to Bateman to court her services. Bateman was more than happy to be engaged and gave William a host of spurious instructions to aid in the healing of his wife, which included sewing money to the bedclothes on which Rebecca slept. The money comprising of four guinea notes was to remain in situ for eighteen months. Bateman then visited Rebecca and supposedly sewed the guinea notes into the upturned corners of the bedclothes to ensure that the money remained in place. Further spurious instructions to the couple followed, such as placing charms around the house and sending personal items, including further monetary payments, to the mysterious Mrs Blythe, an invention of Bateman's who apparently resided in Scarborough (where Bateman was living at the time). The couple dutifully obeyed.

Mary Bateman.

Bateman eventually decided that she wanted rid of the couple and, in a final solution to the spirit problem, suggested that both Rebecca and her husband eat puddings to which they were to add a powder that she had formulated. The mixture was of course highly toxic and took the life of Rebecca within a week; however, William survived, mainly due to the fact that he ate only small doses rather than Bateman's recommended amount.

William was still under the influence of Bateman after the death of Rebecca, and it wasn't until the denouement of the eighteen-month charm regarding the guinea notes that he realised he had been fooled. Unravelling the stitching in the corners of the bedclothes that supposedly held the money, he found instead only a few coins and rotting pieces of cabbage. Furious, William arranged to meet Bateman in a sting operation in which he was to seek further medicine from the woman. Bateman was arrested successfully in the operation by the Chief Constable of Leeds, William Duffield, when the evil woman was found to be in possession of arsenic, no doubt the intended medicine for William.

Mary Bateman was brought to trial for the murder of Rebecca on 17 March 1809 and was soon found guilty. She was hanged at York three days later. Her skeleton is currently in the possession of the Thackray Medical Museum in Leeds, having initially been submitted to the Leeds Infirmary for medical research.

Beryl Burton Mural
Visitors to Morley, just 6 miles from Leeds, might be surprised to see a huge mural painted on the back wall of the Yorkshire Bank depicting the indomitable Beryl Burton (1937–96), the record-breaking cyclist. Born in the Halton district of Leeds, Burton was the most dominant force in women's long-distance cycling in Britain. She won an incredible seven world titles and ninety domestic championships in a career that spanned almost

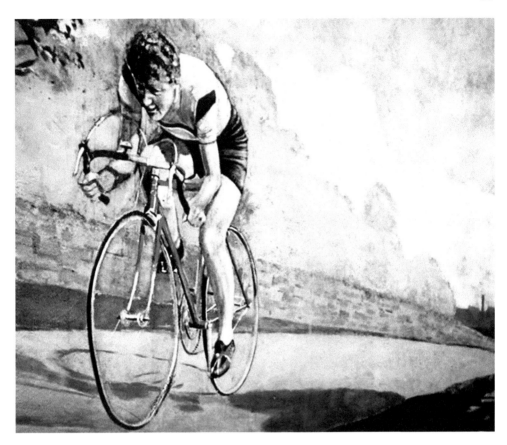

Beryl Burton's mural.

forty years. A woman of unconquerable spirit, her achievements are made all the more astonishing due to the fact that she suffered from chronic health problems, a legacy from having suffered from rheumatic fever when she was a child.

Burton belonged to the Morley Cycling Club, with whom she won most of her honours. In 1967, she set the world record for the twelve-hour time trial, achieving a distance of 277.25 miles, a feat unsurpassed by a male cyclist until 1969. Many of the records that Beryl set stood for decades. The 12-hour time trial still stands as a record for a woman cyclist to this day. A memorial garden was established in Morley in respect of her achievements. Beryl was, somewhat belatedly, inducted into the British Cyclist's Hall of Fame in 2009.

Victorian Cells – Town Hall
Built in 1858, the town hall is one of the most recognisable buildings within the city and is among the largest of its kind in the UK. The town hall nowadays is mainly used as a venue for concerts and civic occasions, however, in the past it played host to unsavoury characters who found themselves on the wrong side of the law. The Victorian Bridewell, or prison, is situated beneath the entrance steps of the town hall. Consisting

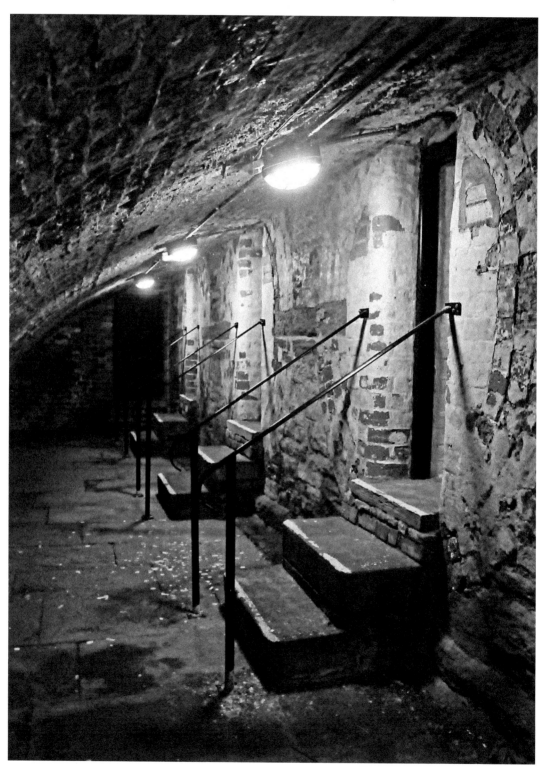

The cells beneath the town hall.

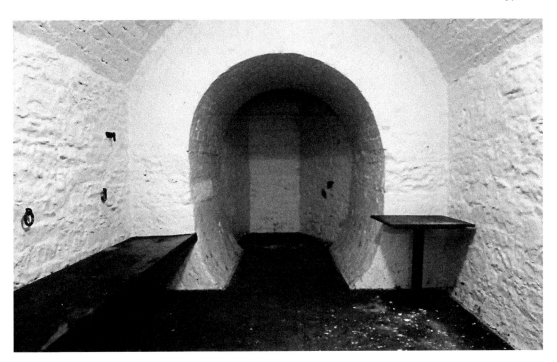

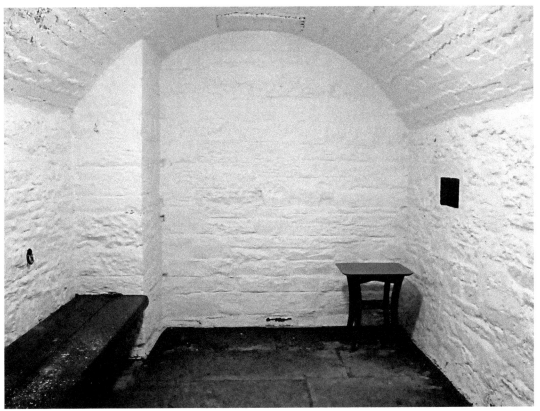

of a series of small and very basic cells, with no window light, life for the prisoners was deliberately made grim. The Victorian's penal vision was to ensure that prison was an effective deterrent to would be criminals as well as for those who might be liable to reoffend. Each cell at Leeds could accommodate up to four prisoners at a time (and often more besides), which would have made overcrowding an issue. The Victorian's did, however, favour solitary confinement whenever possible, as it was believed that hours of enforced silence would facilitate periods of self-reflection in the hope that the offender might realise the error of his ways, but this would have been a rare luxury in the Leeds Bridewell.

The unfortunate inmates within the prison would have lain on the floor with only straw to act as bedding during rest periods. Prisoners who were shackled to the walls would have had to suffer the discomfort of a hard bench rather than the 'luxury' of the straw-laden floor on which to lie. There was no heating in the Bridewell, so in the depths of winter, the inmates would have had to endure the biting cold, existing on paltry meals that consisted of bread, gruel and watery ale if they were lucky. The usual term of incarceration was rarely longer than two days as the prisoners would have been moved on to other more suitable locations depending on their crime.

The cells within the town hall were taken out of service when the prison was expanded and modernised. The town hall bridewell was in use until 1993.

Louis Le Prince

Film directors of Hollywood blockbuster movies such as *Schindler's List*, *Breakfast at Tiffany's* and *The Godfather* might justifiably rest on their laurels, but they must also give more than a passing nod of thanks to Louis Le Prince (1841–90), a French inventor from Metz who, in 1888 while at Leeds, filmed the first ever moving pictures, which earned him the posthumous title of 'The Father of Cinematography'.

Le Prince had moved to Leeds on the request of his friend, John Whitley, who he'd met while at college, and together they founded the Leeds Technical School of Art. There, both Le Prince and Whitley specialised in the fixing of photographic images onto pottery. Their work was so highly acclaimed that portrait commissions were requested from royalty and prime ministers alike.

Le Prince's real passion was photography, especially the moving image. He had designed and patented a single-lens camera, which shot 60-mm spool film. The camera was a rather large and cumbersome piece of kit and was built within a sturdy wooden frame that rested on four squat legs. Le Prince's first efforts committed to film were shot in the grounds of Roundhay. The short sequence of film shows two couples walking in the gardens of the mansion. The images are surprisingly clear given their age.

Le Prince next set up his camera by what is now the British Waterways building and proceeded to film carriages, trams and pedestrians as they crossed Leeds Bridge. These films are available to view on YouTube.

In 1890, two years after his successful moving image capture, Le Prince mysteriously vanished. It is not known what fate befell him, but speculators suggested that the man had committed suicide due to mounting debt problems; however, upon investigation it was found that Le Prince's financial affairs were in good order. Other commentators

Did You Know?

Leeds Bridge is an ancient river crossing. In the thirteenth century, Leeds was a series of burgess building plots on either side of a road called Bridge Gate (now Briggate). There was a wool market at Leeds Bridge, which became the centre of the wool trade in the West Riding of Yorkshire. The bridge was rebuilt in 1870–73 by W. H. Barlow to a design of T. Dyne Steel. The iron was cast in Stanningley by John Butler. It is now a Grade II-listed structure.

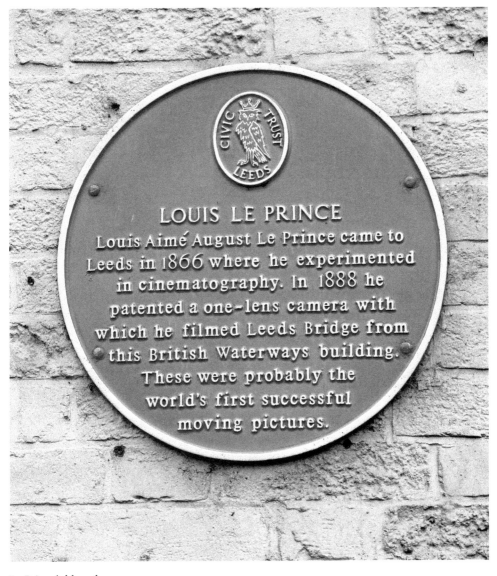

Le Prince's blue plaque.

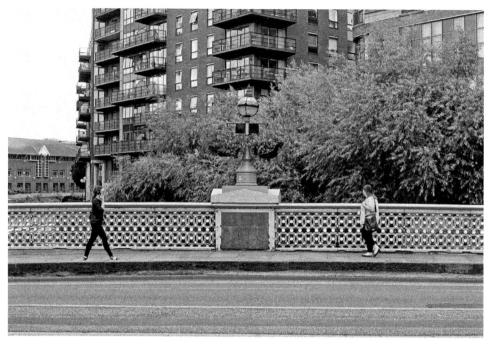

Leeds Bridge.

insinuated that Le Prince may have been murdered by Thomas Edison (1847–1931), who, it was pointed out, was very quick to suggest that it was he who had actually produced the first moving image and not Le Prince. The Lumière brothers were also suspected of being complicit in the man's death, though there has never been any evidence to prove this. Whatever the speculation, the mystery surrounding Le Prince's disappearance has never been solved and remains as much of a mystery today as it was in 1890.

Ellen Heaton

Ellen Heaton (1816–94) was an active campaigner for women's rights and other philanthropic causes, including anti-vivisection, the environment and education. Education was one of Ellen's greatest causes, taking the fight to the authorities in a series of campaigns aimed at ensuring equality for the schooling of girls. Her struggle was set against the backdrop of opinion that did not encourage women to think too deeply or to involve themselves in matters of business or any activity that might inspire independence. Ellen's fight for the reformation of education was strengthened by the founding of the National Union for the Improvement of Education of Women of All Classes, formed by siblings, Maria Grey and Emily Sherriff, both of whom were involved with the suffrage movement, a cause also close to Ellen's heart.

Born in Briggate, Ellen, the daughter of a bookseller, was a keen collector of art and became associated with John Ruskin (1819–1900), the influential critic, humanitarian and social thinker. Ellen was a no-nonsense character, forthright in her opinions and broad-minded, qualities essential for her passionate activism. She

The residence of Ellen Heaton.

ensured that she mixed with those with whom she could engage on an intellectual level and who might be able to aid her in many of her causes. She widened her influence and source of contacts when she became a member of the Leeds Philosophical and Literary Society, founded in 1818. Many manuscripts belonging to the society are now in the hands of the University of Leeds' library.

Ellen was also a member of the Pre-Raphaelite Brotherhood, an organisation formed in 1848 by William Holman Hunt (1827–1910), John Everitt Millais (1829–96) and Dante Gabriel Rossetti (1828–82). All three were accomplished artists who had formed the elite club to critique works of art. Ellen lived up to her indomitable reputation when she upset John Ruskin by disparaging a sensual piece of art by Edward Burne-Jones (1833–98) that he had recommended to her. Ruskin no doubt respected Ellen, but he had in fact misjudged her antipathy towards what

she obviously saw as a piece of work that sexualised women. It was while she was a member of the Brotherhood that she became acquainted with the poet and children's author Christina Georgina Rossetti (1830–94), famous for writing the poem 'In the Bleak Midwinter', which later became a carol set to music by Gustav Holst (1874–1934). On several occasions Rossetti stayed with Heaton at Swarthmore, a row of neat terraced houses now part of the University of Leeds' campus.

It is a testament to Ellen and other strong women of the Victorian era that the restrictive shackles in which women had been held for so long over the centuries were finally loosened. The success of the campaigns fought by Ellen and her associates were often met with limited success at the time, but they paved the way for future generations who were inspired by Ellen and those of the Suffrage Movement to carry the baton forward and push for greater freedom and equality within British society.

Mitzi Cunliffe

Off the beaten track, there are some obscure works of art within the city. If you find yourself close to Leeds University Union, gaze upwards towards the South Clothworkers' Building, formerly the Man-Made Fibres building, and you will notice an interesting sculpture entitled *Man-Made Fibres*. Conceived by the American sculptor Mitzi Cunliffe (1918–2006), famous for designing the BAFTA Awards trophy, the work illustrates beautifully the historic links of the university with the textile industry.

Cunliffe was commissioned by the university in 1954 to produce a piece of art that would gracefully adorn the new Man-Made Fibres building – at the time under construction. She was paid the handsome sum of £2,450 for her work. The design was to be cast in Portland stone, but Cunliffe suggested at a later date that the work should be produced in bronze and gilded in gold, which would have drawn the gaze naturally upwards and to the presence of the work. This idea was resisted by the university architects, who feared that the bronze would stain and the gilding glare under bright sunshine. Cunliffe eventually acquiesced and stuck to the original plan, but kept the bronze maquette she had produced as a prototype for her studio at home.

The *Man-Made Fibres* hand has been recently restored to its former glory, and those with sharp eyes can make out Cunliffe's signature running alongside the bottom of the right-hand thumb.

The Black Prince

Although Edward the Black Prince has no direct connection with Leeds, many people wonder why his impressive statue sits at the heart of City Square. The answer lies in the transition that Leeds made from town to city status in 1893. It was felt that Leeds needed to have a courageous figure of national importance that it could adopt to celebrate this momentous occasion, and the bloodthirsty prince seemed to fit the bill perfectly.

The statue was commissioned by French-born Thomas Walter Harding, mayor of Leeds between 1898 and 1899, and coincided with the creation of a new open space within the square. The work was undertaken by sculptor Thomas Brock (1847–1922), who cast the statue in Belgium as there were no facilities large enough to contain the work within the

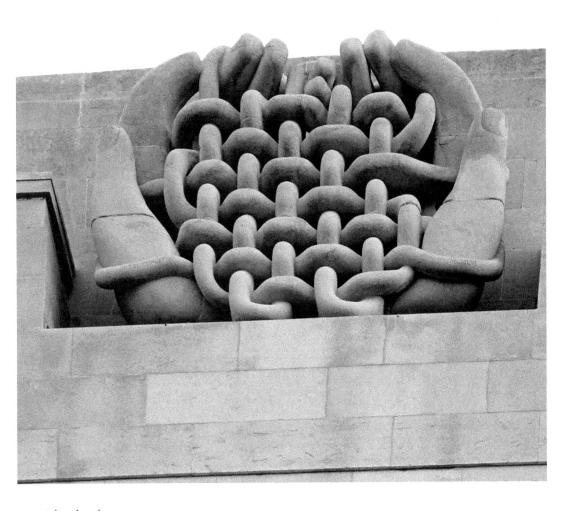

A hand sculpture.

Did You Know?

The first X-Ray spectrometer was invented in Leeds by William Henry Bragg (1862–1942), working in conjunction with his son William Lawrence Bragg (1890–1971) at the city's university. Their work with the spectrometer helped to uncover the structure of crystals and DNA. Both were awarded the Nobel Prize in Physics for their work.

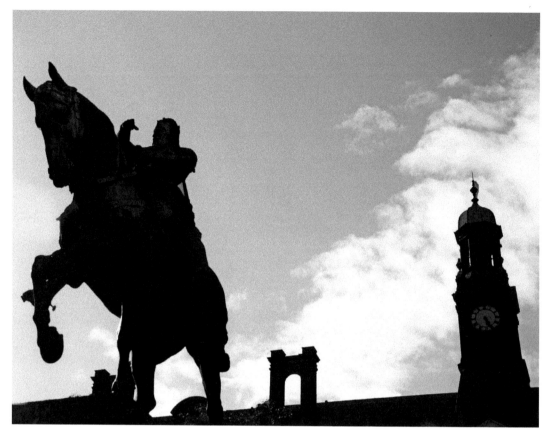

The shadow of the Black Prince.

UK. He worked on the sculpture for seven years before it was eventually ferried by barge to Leeds via Hull and the River Aire. The work was unveiled to the public on 16 September 1902 to great acclaim.

The Dreamer/Floating Woman

This alluring and exquisite piece of art can be found in the secluded courtyard of the Clothworkers' Building within the university campus. The creation of Quentin Bell (1910–96), nephew of the author Virginia Woolf, the work was influenced by the 'levitating woman' illusion, which had impressed him when he was a child. The statue is known by several names: *The Levitating Woman*, *The Dreamer* and *The Astral Lady*, though Bell himself gave the piece a working title of the *Elmdon Figure*. It is another fine example of the many hidden works of art that can be found within the city.

Owen (Owney) Madden

Although Leeds can pride itself on being the birthplace of famous personalities such as Peter O'Toole, Alan Bennett and Mel B (Scary Spice of the Spice Girls), it is a little-known fact that it is also the native city of one of the most notorious gangland crooks of the early

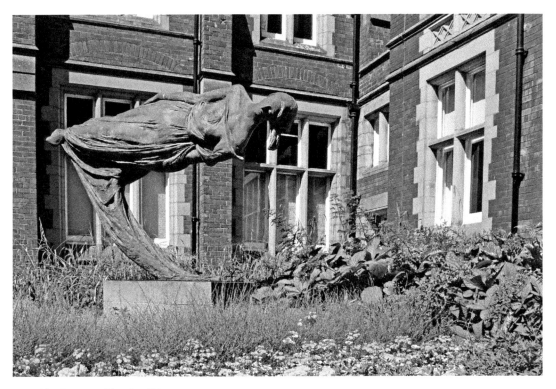

The Dreamer/Floating Woman.

twentieth century.

Owen, infamously known as Owney Madden (1891–1965), was born in Somerset Street near Quarry Hill. It was a rough neighbourhood where many of the inhabitants were employed in the local workhouses. Madden's family were of working-class Irish descent and intended to move to the United States to make a better life for themselves after a short time working in England to raise the necessary funds to cross the Atlantic. When Owney's father, Francis, died his mother sailed to New York to stay with her sister, also a widow, leaving Owney and his brother Martin in the care of a children's home in Springfield Terrace, Leeds. When his mother had sufficient funds to bring Owney and Martin over to the US, the family was able to establish their roots within the large Irish community in a particularly rough area of New York known as Hell's Kitchen. It was here that Madden's character was forged into that of a ruthless killer, gang leader and street fighter.

As Owney grew into adolescence, he came to the conclusion that the only way out of his life of poverty was to earn a dishonest living. Having had no real schooling, he found acceptance and purpose by joining the Gopher Gang (pronounced 'goofer'), an organisation that terrorised, and eventually controlled, major areas of Manhattan through the implementation of protection rackets, murder and burglary. When he was only fourteen years old, Owney had savagely beaten a man, relieving his victim of $500.

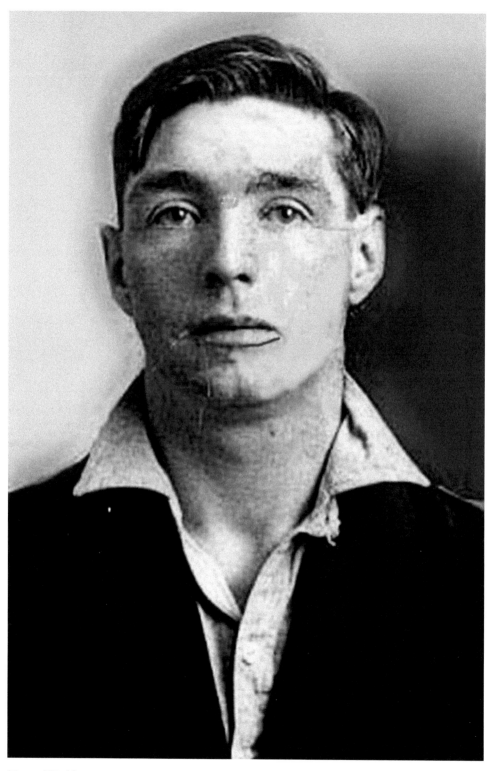

'Owney' Madden.

Owney soon saw his finances improve and a lucrative and somewhat chaotic lifestyle was born.

Owney eventually earned himself a reputation that was feared by many, such was his ruthless passion for his cause. He soon found himself rising up the hierarchy of the Gopher Gang and became a boss. He earned the nickname as 'The Killer' when he shot an Italian gangster in the suburbs of Manhattan. It wasn't long before further blood was shed as Owney's reputation and capacity to make enemies grew.

In 1915 Madden was sent to prison for his part in the murder of Little Patsy Doyle, a high-ranking figure of the rival gang the Hudson Dusters, with whom the Gopher Gang had engaged in many a shootout. The central figure in the dispute had been a woman by the name of Freda Horner, a girlfriend of Madden's, whom he suspected had been having a secret fling with Doyle. Madden had threatened Doyle in a fit of jealousy, and in retaliation Doyle went to the police and told them of Madden's illegal activities. Madden, on a pretext of making peace, arranged to meet with Doyle and killed him. Madden was paroled after only nine years of the twenty years he was sentenced. On his release, Madden quickly got back to business and was involved in the supply and manufacture of alcohol during the Prohibition period, which saw his personal wealth increase. He also opened underground bars and nightclubs, the most famous being the Cotton Club, which showcased jazz music and featured many of top entertainers of the period.

With the end of Prohibition in the early 1930s, Madden realised that his lucrative business empire was under threat and entered into partnership with Bill Duffy and George Fox DeMange to promote boxing, successfully guiding the careers of Max Baer and Primo Camera, who became world heavyweight champions.

Madden, however, was still entangled in bitter gangland rivalries. He was involved with the murder of Vincent Coll, known as Mad Dog Coll, who had been threatening both Madden and DeMange for money; Madden, not taking kindly to threats and blackmail, had the man killed. He was sent back to prison for parole violations, but on his release found a changing world where the authorities were cracking down heavily on the underworld mobsters, and Madden in particular was watched like a hawk. He decided that he would build a new life in Hot Springs, Arkansas, where police surveillance could still be bribed to look the other way. While there he married Agnes Demby, daughter of the postmaster; however, he continued with his corruption and deceit until his health started to fail. In April 1965 Madden died of emphysema.

4. The Name Game

Many street or place names have an origin that is obvious: Station Road will pass the local station, for example, or maybe did so at one time if the station is long closed and gone. Other names are not as obvious, so their origins are harder to discover.

There are eleven other places around the world called Leeds: one in Kent, England; nine in the United States; and one in Canada. The origin of the name of the Leeds in Yorkshire, the subject of this book, dates from Anglo-Saxon times. The Venerable Bede of Jarrow called it Loidis. It gained this name from the Forest of Loidis, which covered the Kingdom of Elmet in the fifth century, an independent Brittonic kingdom that became the West Riding of Yorkshire in AD 889. The name Loidis is Saxon, derived either from *loid* meaning 'a people', or Loidi, the name of the first Saxon owner.

But what about other Leeds place names? In this chapter we try to discover the meanings of some of the most unusual names and a bit more about the places themselves. So, let's play the name game...

Armley

Armley is now probably best known for its prison, which opened in 1847. The prison has 551 cells spread through six wings. Armley itself dates back much earlier, having

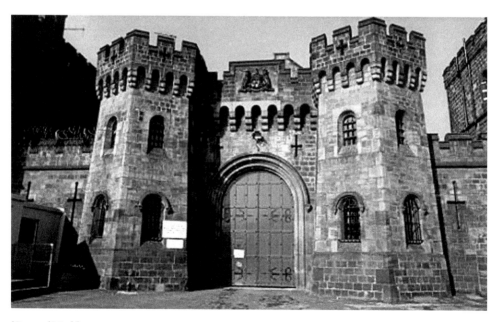

'Owney' Madden.

been recorded in the Domesday Book (1086) as 'Ristone, Ermelai'. At that time there were eight villages in Ristone, which is now east Armley. Over the years 'Ermelai' has become Armley. Only heads of households were counted in 1086, so the actual population cannot be determined. The old Armley mills, dating back to the mid-sixteenth century, are now the Armley Mills Industrial Museum. In 1788, Colonel Thomas Lloyd, a cloth merchant, bought the Armley mills and rebuilt them. At the time it was the world's largest woolen mill. In the eighteenth and nineteenth centuries, the Armley mills contributed much to the prosperity of the City of Leeds.

Many of the present buildings in Armley were built in the 1800s, including a number of churches, schools and houses. Ledgard Way is named after the entrepreneur Samuel Ledgard, who operated a large fleet of buses. William Tetley started his business as a maltster in Armley in 1700 and from this Joshua Tetley founded his famed brewery in 1822.

Beeston

Beeston first appears in the Domesday Book as 'Bestone', when it had recently been granted to Ilbert de Lacy (1045–93); in 1066 it had been worth 40s but by 1086 it was considered waste, probably due to the Harrying of the North – a series of campaigns by William I to subdue the North, resulting in much of the land being laid to waste. The name Beeston is thought to come from the Old English *bēos*, meaning 'bent-grass', and *tun* meaning 'estate' or 'village'. The origin of the settlement is likely to be Anglo-Saxon. It was one of the ten 'out-townships' of the parish of Leeds until it was broken up in the 1840s to 1850s.

Fulneck

Fulneck is a Moravian settlement village in Pudsey. It was established in 1744 and is named after Fulneck (Czech: Fulnek), the German name of a town in northern Moravia, Czech Republic. The village lies in a picturesque location on a hillside overlooking a deep valley. Pudse Beck flows along the bottom of the valley.

Members of the Moravian Church settled at Fulneck in 1744. They were descendants of the Czech Unity of Brethren, who had first sought refuge in Saxony from religious persecution before moving on to Fulneck. Within a few years they had built housing, schools and a chapel. The chapel was completed in 1748, the boys' school in 1753, and the girls' school in 1755. In 1994 the two were merged and continued as a single independent school.

Gipton

Gipton derives from Old English. The first element 'Gip' is from a personal name – Gippa. The 'tun' means a village, settlement or farm (here, it refers to a village). The town's name was recorded as 'Cepetun', suggesting a village with a market and a trading town, or residence of the traders. The name 'Coldcotes', which prefixes many of the area's street names, comes from 'cold cottages'. Gipton Spa, or bathhouse, is in what is now Gledhow Valley Woods.

Headingley

Headingley is first mentioned in the Domesday Book (1086) as Hedingelei or Hedingeleia, where it is recorded that Ilbert de Lacy held 7 carucates (around 840 acres) of land.

The name is thought to come from the Old English *head(d)inga*, which means 'of the descendants of Head(d)a', plus *lēah*, meaning 'open ground', thus the full meaning is 'the clearing of Hedda's people'. Headda has sometimes been identified with Saint Haedde.

From Viking times Headingley was the centre of the wapentake of Skyrack, or Siaraches, the 'Shire Oak'. The name is thought to refer to an oak tree that was used as a meeting place for settling legal disputes and raising armies. An ancient oak, said to be the Shire Oak, stood to the north of St Michael's Church until 1941, when it had to be removed as the tree was dead and a potential hazard. It gives its name to two pubs: the Original Oak and the Skyrack.

Holbeck

Holbeck first appeared as a place name in the twelfth century in forms such as Holebec and Holesbec. They are derived from *hol* meaning 'a hollow' and *beck* 'a stream' (which is taken from an Old Norse word *bekkr*, showing the Norse influence in Yorkshire during the Viking age), thus its meaning is 'stream in the hollow'.

The old manor belonged to the priory of the Holy Trinity at York, and after the Dissolution of the Monasteries it passed to the Darcy and Ingram families. In the eighteenth century Holbeck was known for its spa water, which resembled that of Harrogate, and was carried into Leeds to be sold for medicinal purposes. The supply diminished when numerous wells were sunk to supply the mills and works in the area and the water, which previously rose to the surface, could only be obtained by pumping from a great depth.

Hunslet

Hunslet is first mentioned in this form in the Domesday Book. However, twelfth-century spellings of the name, such as 'Hunsflete', show that there was no standard spelling of any names at that time. The name appears originally to have meant 'Hūn's creek', from an Anglo-Saxon personal name Hūn and the Old English word *flēot* meaning 'creek' or 'inlet', probably referring to an inlet from the River Aire. At the time of the Domesday Book in 1086, the manor belonged to the Lacy family, from whom it passed to various families including the Gascoignes and the Neviles. Hunslet was the birthplace of Thomas Gascoigne, born in 1404 and later chancellor of the University of Oxford in 1442 after several years as vice chancellor. (See Chapter 1 for an account of the Middleton Railway, which runs from Hunslet to Middleton Park.)

Kippax

Kippax is an Anglo-Saxon name and is first found as 'Chipesch' in the Domesday Book, as 'Kippeys' in charters from the 1090s to the 1270s, and 'Kypask' and 'Kypax' from the thirteenth century onwards. The place name appears to be composed of an Anglo-Saxon personal name 'Cippa', suggested by the Domesday Book form, or *cyppa* meaning 'ash-tree'. This might mean that the village was first established in a wooded area of ash trees. The pronunciation of the name seems to show Scandinavian influence.

Meanwood

Meanwood has an Anglo-Saxon name that goes back to the twelfth century; the 'Meene wude' was the boundary wood of the Manor of Alreton, the woods to the east of

Meanwood Woods in winter, *c.* 1907 (from an old postcard).

Meanwood Beck. Dwellings and farms near the wood were known by various names, including Meanwoodside, until the parish of Meanwood was established on 27 August 1847 and the woods became known as Meanwood Woods.

During the Civil War a skirmish took place between Royalist and Parliamentarian forces in Meanwood. It is said that the 'beck ran red' with the blood of the fallen, hence, the place name Stainbeck.

The Meanwood Valley was a place of industry as long ago as 1577 and continued up to the nineteeth century. The Meanwood Beck provided water and power for corn, flax and paper mills, dye works and tanneries, and there were numerous quarries.

Morley

Morley is first mentioned in the Domesday Book as 'Morelege', 'Morelei' and 'Moreleia'. The name comes from the Old English *mor*, meaning 'moor, clearing or pasture', plus *leah*, meaning 'open ground or clearing' – thus giving 'moor in open ground'. During the eighteenth and nineteenth centuries it played a major part in the textile industry, especially in the manufacture of shoddy cloth. Recycled wool was made from old clothes by grinding them down into fibres that could be respun as yarn. This technique was invented by Benjamin Law in 1813. Because shoddy cloth is inferior from newly manufactured cloth, the term 'shoddy' has come to mean anything that is inferior or of poor quality. Large quantities of shoddy cloth were exported to America during the American Civil War and used for uniforms by both sides.

Pudsey

Pudsey is first recorded in the Domesday Book as 'Podechesaie' and also 'Podechesai'. Its origin is thought to derive from a reputed personal name, Pudoc, and the word *ēg* meaning 'island', but in this sense it likely refers to an 'island' of fertile ground in moorland. Thus, the name would have the meaning 'Pudoc's island'.

Around 1775 a cache of a 100 silver Roman coins, with some dating from before the time of Julius Caesar, was found on Pudsey Common by Benjamin Scholfield of Pudsey at a place known as King Alfred's Camp.

The town was famous in the eighteenth and nineteenth centuries for wool manufacture.

Yorkshire and England cricketers Sir Len Hutton, Herbert Sutcliffe, Ray Illingworth and Matthew Hoggard all learned their skills playing at Pudsey.

Robin Hood

Robin Hood is a village just west of Rothwell. It has tenuous links with the medieval folk hero Robin Hood, from whom it gets its name. Some of the original legends do mention an 'Outwoods' (most likely the Outwood of Wakefield, just south of Robin Hood) and the original legends also mention a 'Stane Lea' (the nearby village of Stanley). Most of the original Robin Hood ballads have him operating in and around Barnsdale Forest, which is close to Wakefield, and the surrounding areas. There is controversy about the truth of the legends recording the deeds of Robin Hood. Whether he really did rob the rich to give to the poor or was simply a local bandit we will never know, but meanwhile the legends persist.

Sir Len Hutton.

Waterloo Lake, Roundhay Park, *c.* 1907 (from an old postcard).

Roundhay

Roundhay gets its name from the Old French *rond*, meaning 'round', and the Old English word *(ge)hæg*, meaning 'enclosure', describing a round hunting enclosure or deer park. A Roundhay estate map from 1803 shows its circular shape. Roundhay does not appear in the Domesday Book, but is thought to have been created soon afterwards as a hunting park for the Norman noblemen of the De Lacy family and their guests, the first mention being in around 1153. Coal and iron ore were once mined in the area and a smelting furnace was recorded in 1295. Once these resources were exhausted and the woodland had been cleared, the area was given over for farming

Modern Roundhay is a popular residential suburb of Leeds with good leisure facilities. Roundhay Park is quite extensive with pleasant walks and a large lake. There is also the popular attraction of Tropical World next to the park with a remarkable collection of tropical wildlife and plants.

Swillington

Swillington is first recorded in the Domesday Book in the forms 'Suillictun', 'Suilligtune' and 'Suillintun'. Its origins are uncertain, but it probably derives from Old English *swīn* 'pig', plus either *lēah* meaning 'open ground' or *hyll* meaning 'hill'; then there is *ing*, a suffix which in this case marks the word as a place name, plus *tūn* meaning 'estate or farm'. The *Dictionary of British Place Names* gives a derivation meaning 'farmstead near the pig hill (or clearing).'

The name was recorded as 'Svilentone' in 1147. Historically, Swillington's full title was Swillington-in-Elmet, which takes account of the village's association with the early medieval polity of Elmet. However, as with many other places, the '-in-Elmet' has been lost in modern times; only a few exceptions survive, such as Barwick-in-Elmet and Sherburn-in-Elmet.

And Finally...

If your local community or area is not represented above you can play the name game yourself. Google the name and see what comes up, or call into your local library and ask the staff what they can find for you.

5. Cryptic Customs

The Strange Ways of Leeds Folk

What does it take for something to be classed as a custom? Tying your shoelaces could not be described as such, nor could charging your phone. These are purely practical matters. However, if you always tied your shoes once, undid them and then retied them, we could perhaps say that was your custom. Likewise, if a certain community charged their phones only at a certain place at a certain time of day, regardless of the practical considerations, that might constitute a custom. If we do something repeatedly and there is no completely rational motivation for doing it the way we do, then we'll call it a custom. There is something a little irrational about customs, therefore, and perhaps even something peculiarly human. And for every tradition or custom that is peculiar to Leeds, we glimpse something of the peculiar humanity of this great city. For instance, did you know that the people of Leeds have their own modern stone circle? Built in 1997 at Thwaite Mills Museum with details carved by the artist, Melanie Wilkes, this is a beautiful fusion of the old and the new and is a delight to visitors and a place of continuing significance to local pagan groups.

The stone circle at Thwaite Mills, a popular spot for new customs and old.

Standing stone at Thwaite Mills. Melanie Wilkes' carvings represent the fair winds.

In this chapter we look back as far as history will allow to some forgotten practices – some of which might surprise the modern reader – and forward to the present day to find some things that might have given our ancestors a bit of a shock too.

The Secret Language of Bairns

Like children the world over, Leeds kids have managed to evolve their own ways of communicating – sometimes in order to imitate adults around them – sometime merely to baffle them. The following words and phrases were recorded by children in Leeds and the surrounding area nearly sixty years ago. Many of them were old at the time and indeed many of them are still used today.

Touch black, no back

Having limited access to currency (or exhausting it rather more swiftly than may be wise), children quickly learn the power of the swap. This process provides a powerful lesson in bargain-making and honesty. Surrounding the exchange is the ever-present possibility of the swapsie equivalent of 'buyer's remorse', which can lead to one party wanting to reverse the deal. In such cases, children up and down the land have evolved little phrases that emphasise that a deal, once struck, is not to be reversed.

In Leeds this comes with a little ritual reminiscent of touching wood. The insurance used is to touch something black and cry 'touch black, no back', ideally in the presence of witnesses. Whether this truly secures an irreversible deal is not certain.

Foggy and Ferry

Another point of tension in the life of the child is how, in a competitive world, to secure first place, the front of a line, the next kiss etc. Again, the children of Leeds have a way to nab this ahead of all competition. In common with Humberside and North Yorkshire, a child shouting 'foggy' can claim the right to first go but, owing to the geography of the town, it is also possible to use the Pennine term 'ferry' – more common in Huddersfield, Bradford and Halifax. While at first glance these words appear cryptic, the likelihood is they are corruptions of 'first' or 'first go' and there are recorded instances of a whole series 'seci', 'thirdy', 'fourthy' and so on, all the way to 'laggy' (last go).

Ballow and Bags

Another use of 'ferry' for first is to stake a claim to ownership, although this is not universal. Probably the most common term in Britain for this is a variation on the theme of 'bag' – also called 'bagsy' and 'baggy'. But in the West Yorkshire area around Leeds it has been known for children to use the word 'ballow', as in 'I ballow that' or 'I ballows it'; it is shortened sometimes (as is the Leeds way) to 'balla'.

Alley, Alley, Aster

In adult life, chanting is reserved for the football terrace, the church service, and the political rally. In childhood, however, chants have served a great many purposes. One such phrase recorded in Leeds has been used by children trying to drive an adult to accelerate a playground roundabout: 'faster, faster, alley, alley aster', repeated ad nauseam

Old spice, sweet treats for generations of Leeds children.

(quite literally in some, regrettable, cases). A less effective but no less enthusiastic chant is directed at winter weather – 'snow, snow, faster, alley, alley, aster' – and is employed especially on days when there is uncertainty about whether a school will manage to open that day.

Spice and Spaw Water

For reasons lost to history, Leeds and the surrounding parts of West Yorkshire have traditionally recycled the word 'spice' to refer to sugary confectionary – as in the phrase 'Mam, 'e's got spice and I a'n't got none'. This term is rapidly losing currency, and with it a treat all but lost to the advance of cheap sweets: liquorice root – once grown not very far away in Pontefract. This was chewed and eaten like sweets for many years; it also became the basis for a drink called variously 'sugarolly water', 'Spanish juice' and 'poplolly', which is made by smashing up a piece of liquorice root and leaving it in a bottle of water with large amounts of sugar to steep (or mash) for as long as possible. Once the child's patience was exhausted he or she would retrieve the bottle, which would now be filled with a strange dark beverage much enjoyed by its maker. To regard this as 'spaw water' (presumably a corruption of 'spa water') requires the power of a child's imagination.

'Spaw' Water, making pop the old fashioned way.

Did You Know?
Brian Boffrey, born in the Horsforth area of Leeds, invented the Jelly Tot sweet whilst he was employed at Rowntree's of York. Boffrey had been experimenting with the production of quick-set jellies and discovered that by adding colour and flavouring to the tiny droplets of jelly created by the experiment produced what was to become one of the UK's best loved sweets.

Custard Lugs
From the same place that brought us the term 'cowardy custard' and the general 'yellow' to mean timid or fearful, comes the Yorkshire term 'custard lugs', which seems unlikely to impart any serious motivation to its victim but does provide a charming image for any audience.

Tread on a Nick
Likely now retired is the following rhyme, once recorded in the district and repeated whenever someone trod on a gap between paving:

> If you tread on a nick
> You'll marry a brick
> And a beetle will come to your wedding.

One wonders whether this was ever said to a close friend of one the Fab Four, in which case a slight respelling may have made the line prophetic.

Taws and Gollies
Taws was a marbles game played in Leeds on soily ground, well-flattened by people walking across it. Smaller glass balls (taws) were just called 'marbles', whereas the larger ones were called 'gollies'. In one game, a square was carved in the ground with a stick and up to four small taws, belonging to the various players, would be placed one at each corner, with players taking turns to try to bounce their opponent's taws out of the square.

Sex and Witchcraft in Rothwell

In modern times, the word 'fetish' seldom appears without a subtext suggesting something out of the *Fifty Shades of Grey* or things hidden in the more curious corners of the internet. Prior to this (and in a more technical sense) the term referred to a ritual or magic object held in great regard in certain societies around the world.

It appears that concerning particular matters occurring in Rothwell in the seventeenth century, we could use 'fetish' in both senses at once to describe a curious item belonging to one Katherine Earle – sometimes known as the Rothwell Witch – and the activity accompanying it.

Regrettably, surviving records that give a sympathetic account of women named as witches by court and other official records are very few (see the section on Mary Bateman in Chapter 3), but a more understanding posterity has often come along to redeem them. The crimes that many of these women appear to have been guilty of included being old, sometimes (although not always) to have been unmarried, and also to have 'known things'.

The lattermost of these crimes may have been the most provocative. In days when European medicine was not very advanced and gynaecology virtually non-existent, it was necessary for communities to turn to whoever knew a little more than they did. So, by the law of gravitation of experience, certain people would emerge as specialists in treatments and cures; where the difficult and emotive issues of childbirth and fertility were concerned, this would often be the preserve of women, particularly those who had come through the process themselves.

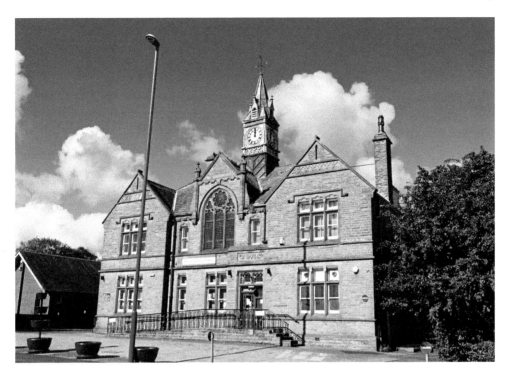

Rothwell Council offices, built in 1898.

It seems likely that such a person was Katherine Earle of Rhodes in Rothwell, who had served as a wet nurse in her youth and later lived with the rest of the Earle family in the improbably named Cheesecake Farm. She appears in several places in the records and was accused of witchcraft at various places.

One of the charges brought against her was heard by Sir John Savile at Wakefield. The charge read:

> She did connive with Satan to make barren wives bear children. Begot by the spawn of a Devil in the shape of a Great Oak Man who dwelleth in a hut in the garden of Cheesecake Farm, at Rhodes, Rothwell, in the said County of York, where the said Katherine do dwell.

Did You Know?

The Leeds coat of arms has three owls adorning it from the coat of arms belonging to Sir John Savile, the 1st Alderman of Leeds. The Savile family came from Anjou in northern France and were supporters of William the Conqueror. After his conquest of England he rewarded the Savile's with a large area of Yorkshire. Their coat of arms was a sash with three owls on it.

The remains of Rothwell Castle, already a ruin in Katherine Earle's day.

A twentieth-century account of her story (by a writer who did not make his name abundantly clear, referring to himself only as 'The Author, John Overend House, Rothwell') connects the Great Oak Man to an account from South Africa in the mid-twentieth century. It seems that around dusk in a certain place in this part of the world, women from a wide area would congregate at a river island whereon sat a hut with strange markings and bones and skulls hung about it. This was known as the 'Island of Women with No Seed' and was frequented by married women who had yet to become pregnant. 'The women who visited there did so for one reason only' runs the account, 'to connive with the stone phallus, kept there for the purpose, and to pray to pagan gods for the grant of bearing a child.'

This unlikely liaison sometimes achieved its aim and the women eventually became pregnant. Our nameless author suggests the same thing was happening in Katherine Earle's hut in seventeenth-century Rothwell.

Interestingly, more recent research has led some authorities to claim that reaching climax after sex (whether by human agency or otherwise) can bring about improvement in the chances of conception – sometimes hours or even days after the initial act. It may even be that, for local women, skilful application of the Great Oak Man fetish made up for their husbands' shortfalls in the bedroom arts and resulted in the perpetuation of the line of many Rothwell families.

Whether Katherine Earle fully understood this is now impossible to say. Happily, however threatening her knowledge of fertility matters may have been to some, she never was found guilty of witchcraft. She eventually died of natural causes on 23 May 1661 and was buried in Rothwell churchyard.

Feasts, Fights and Quidditch on Woodhouse Moor

With the continuing accretions of time and tradition, Woodhouse Moor provides an increasingly rich leisure environment and while very few of these activities are genuinely secret, some are sufficiently obscure as to merit inclusion in this collection whereas some, sadly, appear to have died out and thus merit a record of their passing.

Cinder Moor. Home of feasts, fairs and the park and ride.

The Great Moor (and the neighbouring Little Moor or Cinder Moor and Monument Moor) play host to numerous events and celebrations, such as Hyde Park Unity Day (a day intended to facilitate community cohesion founded in the aftermath of a period of rioting) and various fairs – including the celebrated Woodhouse Feast. The Woodhouse Feast of the 1920s was recalled by one Rose Green of the Woodhouse Local History Group as follows:

> Looking back, one realises that the coming of 'The Feast' in September was probably the highlight of the year. The Easter Feast on the small Cinder Moor was but a pale shadow of the 'Big Feast'.
>
> I remember running home with the important news (to me anyway) that a caravan had arrived which heralded the joy of things to come.
>
> Watching all the men putting up the rides and side shows was all part of the excitement. I remember 'The Whip' – if you weren't careful your head felt as if it was coming off. Then there was 'The Shamrock', a huge type of swing as big as a bus – or so it seemed – that almost stood on its end as it swung to and fro. It terrified me! I only tried it once ... Then there were the big horses which we rode majestically round and round, and the chariots and the beautiful organs pumping out stirring tunes.

The community element made this more than just a fair. Another local, Betty McHale, reflects on the somewhat acidic choice of snack the people of Leeds once enjoyed: 'Lots of people used to do pickled onions and red cabbage, as family and friends would call at Feast time for a sandwich and pickles. My father used to do pickles for my grandma.'

The health and safety industry was probably in its infancy at the time as Rose goes on to explain,

> I loved watching 'The Wall of Death'. We all stood on top of the barrel-type structure looking down into the centre where a motor bike and side-car was revving. A volunteer was asked for to ride in the side car and away it sped, higher and higher, until we had to step back in case our noses got caught as the contraption flew past.

Fairs still arrive on the Moors at Woodhouse but the feast was something special. It was commemorated for a time in the name of a pub that preceded The Library and was called the Feast and Firkin.

Some Woodhouse traditions are, by contrast, a little more equivocal. The liberal and unofficial splashing around of paint raises temperatures in some quarters and the graffiti artist Banksy is a hero to some and a villain to others. The tradition in this area of Leeds, however, has often led to some quite creative and sometimes amusing graffiti, which might give the harshest critics pause for thought.

One act that seems to have amused generations of students is called 'Booting the Duke'. This act of vandalism requires the participants to scale the statue of the Duke of Wellington, which stands around 2 metres above the ground in the south-east corner of the moor. They then daub the footwear of the eponymous boot-wearer in red or orange paint, so as to highlight his best-known feature. The fact that this feature never seems

Wellington and his boots.

A roar deal? The Woodhouse Moor Lion at its most colourful.

to disappear but is renewed year after year suggests the council has long since given up trying to return the Duke to how his maker intended.

Another painting enterprise once involved repainting the stone lion that stood in the centre of the moor. This fierce character – the noble steed of many a small child – was depicted in battle against a snake, supposedly to represent Britain's victory over France. At the end of their final term at university, students would give the lion a fresh coat of paint – sometimes in the brightest of colours. Sadly, the council moved and then eventually removed the beast and the tradition came to an end.

Less controversially, the moor makes an excellent venue for sport – primarily the more commonplace sort, such as crown green bowling, tennis and skateboarding, for which facilities have been in place for many years. There are strict rules in place governing what can and can't be played on the various moors, partially because, at a time when the need for fresh air at an elevated location (like that of The Moor) was growing considerably owing to increased industrialisation, the playing of a particularly hazardous game called Knor and Spell was commonplace. This involved whacking a solid wooden ball, the knor or knurr, with a steel stave or spell, which first had to be popped from its brass cup at the end of the spell by means of a spring. The aim was simply to drive the knor as hard and far as possible, so the fear of serious injury was a real one.

In more recent times, besides the usual outdoor games that might be expected, one can also encounter some activities not often associated with the playing fields of Yorkshire, such as baseball, medieval armed combat, and, more recently, quidditch.

Woodhouse war. Medieval re-enactors do their thing.

This new worldwide league is inspired by J. K. Rowling in her Harry Potter books. The original magical sport is played on broomsticks, which are retained in the muggle version although smaller, lighter models are permitted.

Other elements include such things as the quaffle, the bludgers and the snitch, which, to the uninitiated, sound as mystifying as the knor and spell. By contrast to the knor and spell, however, even working out what is going on in a quidditch game takes quite some time to learn, which is perhaps why only the keen young minds of the universities have so far managed to master it.

Stealth and Stockpiling in Autumn Time

Mischief Night is one tradition that seems peculiar to the North of England – at least in origin – and until relatively recently had escaped serious academic investigation.

The tradition, which seems to have been particularly strong in Leeds, takes place on 4 November – the eve of Bonfire Night – and has done so for at least 150 years and possibly even longer. On this night, participating children sneak up to the doors of neighbouring houses and play a range of pranks – some fairly innocent, some less so. By far the easiest trick is to knock on the door and run away, making merry at the expense of the disturbed occupant. However, even this simple trick has many variants. For instance, stringing together doors across a street or alleyway and knocking on both so that neighbours tug away against each other in a bid to open their own front door. Another trick is to tie a pin or button on a piece of thread and stick it to a window, hoping that in the darkness the occupant will not see the agent of the ghostly tap-tapping against the glass.

A speedy getaway. Mischief Night requires nimble feet.

The following account comes from Pauline Gardiner of Woodhouse:

As soon as it grew dusk groups of children would go round their streets throwing off the dustbin lids. It was just noisy fun and most of the neighbours accepted the racket for an hour or so the one night of the year. Once or twice we quietly tied a dustbin lid to a doorknob, laid the lid on the steps, then knocked on the door. As the door opened the lid clattered up the steps. (We only played this trick where youngish neighbours lived, never an old person's house.)

It was funny to see the surprised face of the housewife as she opened the door to the great clatter of the lid going up the steps. Once we got a bit of a scare when we were going to tie a dustbin lid to a door. One of us spotted a shadowy figure of a man in the cellar doorway. We all jumped over the garden wall much faster than we'd crept over it! The man grabbed at our 'leader' but he managed to escape. Next Mischief Night we remembered to miss that neighbour's house.

Pauline's account is typical and most of the mischief appears to have been quite minor, but there are older tales of stolen gates, brushes and nameplates with the mischief sometimes spilling over into violence. One tale tells of a trick using a clothes prop to strike the occupant of a house, who pushed his head out to investigate strange goings-on in his own backyard. Another account, recorded in 1902, relates to how a serving maid travelling through Kirkstall was attacked in the street. Her assailants were a gang of youths armed with sticks who sought to justify their actions with the cry 'oh, it's ahl reight missus, it's 'mischief neight,' doan't you knoa?'

Pauline goes on to discuss the different reactions she encountered and implies that the mischief might not always be so forgivable:

Mostly the neighbours were tolerant for that night. The dogs made as much noise of their own barking at us. There were plenty of policemen on the beat to make sure that only harmless 'mischief' was taking place. One policeman stopped our little gang at the top of the street, and said sternly he hoped we weren't 'up to anything'. We stood looking as innocent as we could and said 'no'. When he was out of sight we carried on.

And so the tradition continues, with participating youngsters often excusing themselves with the phrase 'it's nobbut the mischief neet'.

As it transpires, one of the recurrent features of the tradition is that the perpetrators believe they are invulnerable to prosecution on this one night of the year. There is a measure of truth in this in that police and other authority figures have at times been inclined to be lenient with children upholding the tradition – perhaps because they know that in a brief space of time the occasion will be over for another year.

The matter of how Mischief Night came about is not quite settled. There are records of a similar night of pranks that used to occur on the eve of May Day in some parts of the country, and involved depositing flowers and other things on doorsteps. There certainly seems to be a connection with the thrills and excitement children inevitably feel on the eve of a big community celebration. Indeed, one can imagine some parents casting their young

Gate crashers. Anything made of wood is fair game if you can lift it!

out into the street on the eve of bonfire night to get them to burn off any excess energy before bedtime. Giddiness spilling over into mischief does not seem a very great step.

This possibility is strengthened when we look across the Atlantic to the USA, where Bonfire Night is not widely celebrated. In these parts the term 'Mischief Night' has partially come to mean the night before Hallowe'en and although it is sometimes no more sinister than its Yorkshire equivalent, there are occasionally much graver breeches of law and order for the authorities to contend with.

The other activity popular in Leeds on the night before Bonfire Night is known locally as 'chumping'. This involves groups of kids trawling the neighbourhood in search of 'chumps' – chunks, or lumps, of wood or other fuel that can be thrown on the bonfire. Sometimes this is a matter of raiding skips or local woodland, but it has been known to involve stealing wooden objects from yards and gardens and even (during particularly lean years) conducting raids on the accumulated chumps of other gangs – necessitating placing a watch on the precious pile.

There was a time when these two traditions would have been blended rather seamlessly with the serious (and legitimate) practice of chumping, providing excellent cover for more mischievous doings.

The Wassail Box
Later in the autumn came another Yorkshire tradition that is now lost – perhaps even to living memory. This was the custom known as wassailing, in which children in Leeds and the surrounding areas went from door to door with a box called a Wassail Box.

The Wassail Box.

This strange receptacle – for which any relatively clean container will do – is taken by the children and populated with seasonal greenery, treats and some form of effigy. Lastly a purse is added – importantly one with a hole in it.

In the picture you can see a typical example, containing holly, mistletoe, paper flowers, fruit, sweets and two dolls. The perforated purse is present too. The explanation for the two dolls is that they represent Virgin and Child.

For the children's progress around their neighbourhood, the box is covered and the children sing carols to attract the occupants of houses. When answering the door, the children ask if the occupant wishes to see what's in the box. If so, the contents are revealed and a verse sung to invite the audience to spare some money:

> We have a little purse,
> It's made of leathery skin,
> We want a little of your money
> To line it well within.
> Our boots are very old,
> And our clothes are very thin;
> We're tired out with wandering around,
> And if we cannot sing,
> If you only spare a copper
> To line the purse within.
> So God prosper you and I wish you
> A Merry Christmas and a Happy New Year

As the significance of the dolls suggests, this is regarded as a Catholic custom. The origin is a little unclear, but in Catholic countries the parading of statues and icons through the streets on feast days is such a prominent tradition that it seems hard to resist the idea that wassailing, in this form in Leeds, was an echo of that tradition.

Love Locks on Centenary Bridge

Over the last few years, a curious display of padlocks has overtaken the railings on Centenary Bridge. Situated in the shadow of the Royal Armouries Museum, this assortment of locks is adorned with love messages from devoted couples. Reminiscent of the Pont des Arts in Paris, Leeds is now giving the French capital a run for its money in the romantic stakes. The locks are meant to symbolise the strength of unity between two hearts that are permanently locked together. The messages of endearment are there for all to see, yet it is surprising how few people in the Leeds district area are aware of this phenomenon.

The idea of attaching padlocks to a bridge traces its origins to a fable set in Serbia, where a young couple, Nada and Relia, were about to be parted through the outbreak of the First World War. Responding to the call of duty, Relia was sent off to the front lines, only to be killed in action. His devastated sweetheart returned each night to the bridge where they had said their final goodbyes, dreaming and praying for Relia's return. In recognition of this poor girl's heartache, local young ladies placed locks on the bridge

Centenary Bridge festooned with messages of love.

rails, thus securing the love of their boyfriends in an attempt to avoid the same fate that befell poor Nada.

The locks at Centenary Bridge were removed in the autumn of 2016 as Leeds City Council deemed them a potential threat to the structural integrity of the bridge.

6. Fortean Leeds

Strange Beings in Reality and Rumour

Whether we put our faith in it or not, the world of the unexplained is often capable of drawing us in for at least a short time while we entertain the possibility of wrathful spectres, stalking monstrosities, or inscrutable visitors from remote civilisations. Of all the students of such phenomena that there have been, one man seems to have bridged the chasm between outright credulity and unshakable scepticism – Charles Fort.

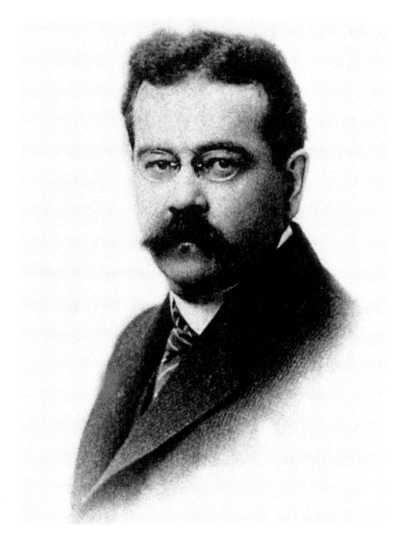

Charles Fort, pioneer of the unexplained.

Charles Fort was born in Albany, New York, in the year 1874. As a young man, full of questions about the world and with an ambition to become a writer, he travelled the world, broadening his horizons and meeting people from all walks of life. During this period he came to Britain and travelled around England and Scotland before heading back to the USA. There he set about his life's work: reading everything he could lay his hands on and making meticulous notes of anything that didn't 'fit' with the established orthodoxy of contemporary life, and writing extensively on subjects such as apparitions, accounts of visitors from other worlds, falls of fish or frogs, or other strange things. In the process, he refused to accept conventional explanations for things – always able to point to those pieces of data that didn't fit in with the scientific orthodoxy of his day. One of his books, *The Book of the Damned*, was the first serious work to consider that we might have already been visited by beings from outer space – a revolutionary idea at the time. However, Fort never went so far as to believe his own conjectures; indeed he even saw conventional 'mystic' explanations of hauntings and mysterious beasts as being too much the product of orthodox thinking. 'I conceive of nothing' says Fort, 'in religion, science, or philosophy, that is more than the proper thing to wear, for a while.'

In later life, when Fort's writings began to win him a little success, he came to Britain with his wife to continue his studies in the British Library. It was a happy time for him when he discovered British beer (a welcome treat for a Prohibition-era American) and some of the strange tales that these islands have to offer. It is not known whether Fort travelled to Leeds during his initial visit or on his second stay in England, but no doubt he would have been keen to explore some of the following tales and phenomena in his studies. Perhaps he even got chance to sample a pint of Tetley's.

Numerous collectors of strange tales and supernatural encounters have followed in Fort's footsteps, such as Terence Whitaker, who compiled many of his findings in *North Country Ghosts and Legends*, or Ken Gore, author of *Haunted Leeds*. In addition, there are many groups who meet to explore and celebrate the unexplained in Leeds. It is to these erudite writers and keen observers that this chapter owes much of its source material.

The Blue Ladies of Temple Newsam, Christ the King School and East Riddlesden Hall

While many places enjoy a chilling tale of a White Lady or occasionally a Grey Lady, there appear to be a cluster of Blue Lady stories told around Leeds.

The first and most famous is told of Temple Newsam House to the south-east of Leeds. Rich in history, Temple Newsam House is reputed to be the birthplace of Henry, Lord Darnley, who was husband of Mary Queen of Scots. At this location, an elderly spirit in blue is sometimes seen moving through the rooms. The earliest recorded incidence was on a winter's night in 1908 when Lord Halifax, then the house's owner, observed the singular shape of an elderly female dressed in a blue shawl. He could just make her out in the firelight as she crossed the room where he sat and vanished into the room next door.

Other witnesses have heard screams of agony in this part of the house as well as witnessing a collection of other spooks. The explanations and theories concerning these apparitions would have kept Fort going for months.

Why does Leeds have more than its share of Blue Ladies?

Then, in west Leeds, we find a Blue Lady with a more universal character. Many variants exist of this phenomenon, which appears to have currency throughout the English-speaking world. Rather than being a straightforward ghost story, the one of the Blue Lady has an element of ritual and of dare. In its local form, indulged in by children at Christ the King Catholic Primary School, Bramley, the participants (preferably alone) should take themselves into the school toilets where there hangs a large mirror. Then, while staring into the mirror, they must recite 'Blue Lady, Blue Lady – I have your Blue Baby,' at which point the lights will go out, the taps will begin to run uncontrollably and, in the midst of all this chaos, a woman clad in blue will appear in the mirror and, with sharpened claws, burst forth to throttle whoever has foolishly taken it upon themselves to summon her.

Whispers being what they are, the location and backstory change with each instance, as do the precise details of the ritual, the rhyme and what is supposed to happen (sometimes the death of the participant). Some theories explain the spectre as the ghost of a woman who lost, or maybe killed, her child – hence the colour of the baby.

This macabre meme has travelled between generations of children at Christ the King for many years. What makes this particularly interesting is that Christ the King School was originally founded by the Sisters of Christ the King – a religious order whose vestments are deep blue. The order is no longer involved in the school but memories are long in this part of Leeds and it may be that the idea of a nun falling pregnant and experiencing the shame of bearing and perhaps disposing of a child made the Blue Lady myth particularly resonant here.

A little further out from Leeds, but worth mentioning in the spirit of Blue Ladies, is an entity encountered at East Riddlesden Hall near Keighley. Terence Whitaker relates a tale told to him by a Mr Atkins of Whitby – a cab driver he once met. The driver was called to collect a late-night fare from the old hall – a very old, dark-stone building hidden away from the main road. However, when he arrived there was no light on and no sign of his fare. Not wanting to let anyone down, he decided to try and find whoever had requested his attendance. A little anxiously, he left his cab and inched around the house, trying, unsuccessfully, to spot a light or any signs of another soul. At one point, while peering through a window, he was encouraged to see the shape of a woman – dressed in blue. He failed to get her attention but came away supposing she was there for a party because she was clearly in costume as a Victorian lady or some such.

When he finally found a way into the house he tried in vain to find the party or the woman he had seen. In fact, except for the very distant sound of some music going on, the house was virtually in silence. However, he did track down his fare: a local woman in the caretaker's room. When Atkins had got her back to his cab he thought to clear a few things up and mentioned to his passenger his encounter with the lady in blue, whereupon his fare went very quiet. Presently she looked up and said 'Do you know? You have seen a ghost.' Mr Atkins is adamant he saw the woman in the house that night but as to who this blue lady might have been, it is perhaps now impossible to know.

Monsters and Mysterious Beasts – The Cryptozoology of Leeds

Seekers after strange beasts and monstrous things, or cryptozoologists, as they like to be known, use the word 'cryptids' to describe their quarry. Any creature can be a

The Thylacine or Tasmanian tiger. Has it really died out? This one at the Leeds Discovery Centre certainly has.

cryptid as long as it's thought that it 'shouldn't really be here'. That includes classical monsters such as dragons and harpies but it might also include things usually regarded as extinct such as dinosaurs or the Tasmanian tiger, as well as things that are a long way from home – an alligator in the sewers or a lynx in the Devon countryside for instance.

Bigfoot and Nessie are, of course, the king and queen of all the cryptids and finding evidence for either of them would represent the dream of any cryptozoologist. No Leeds cryptids are even rumoured to exist on quite this scale but a city of this size may just have a few cryptozoological surprises in store.

Bogs, Bugs, Boggards and Bogeys
Throughout the North of England the term for an unpleasant sprite or goblin was usually one of a family of words, including Boggart, Bogle, Bog, Bug and Boggard. There are other possible derivations but the most common theory is that this is connected with the Welsh word *bwg*, meaning 'a ghost or spirit'. There are so few Welsh borrowings in the English language that it's probably as well to share one explanation as to how this one established itself. Following the incursions of

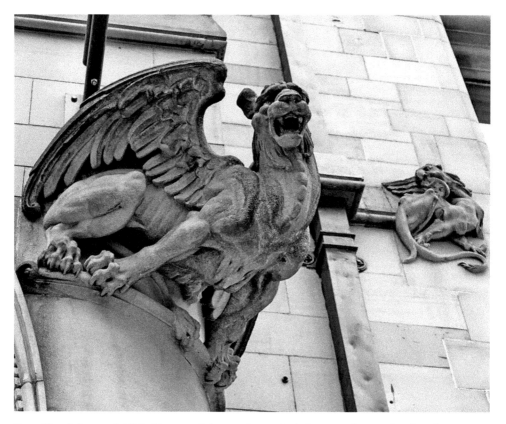

One of Josph Lawson's 'Ugly Monsters'? Strange beasts look down on the people of Leeds.

the Angles, Saxons, Jutes and others during the fifth to seventh century AD, the dominant language of the British Isles was a version of English (Anglo Saxon or Old English as we know it now) that, over time, became mingled with Viking Danish, Norman French and many other languages. However it is now thought that although the language changed, much of the root population of British speakers (originally speaking something resembling modern Welsh) stayed put and remained in thrall to their new overlords. As often happens in such cases, the ruling elite (whether English, Viking or Norman) recruited their servants and slaves from the native population and this would have of course included nurses and midwives. As a result, so the thinking goes, these canny British woman, who were expected to use English when speaking to their masters' children, would at times make reference to their native gods and demons – especially when frightening their English-speaking charges into behaving. Hence, instead of children being threatened with the orcs and dwarves of the English tradition, or the goblins and ogres known to the French, the older British bogs and bogies retained this role and the word has thus survived with the special sense of a means to keep children in check.

Whether this is true or not, the role of boggards and their ilk as things with which to scare children was retained in Leeds and the surrounding area well into the twentieth

century. The following chant sung on bonfire night was recorded in Halifax, around 16 miles from Leeds, in 1971. The newspaper account does not reveal the age of the informant, but given the use of regional dialect and its similarity to verses reported elsewhere, the song itself gives an impression of its longevity, possibly dating from the late nineteenth, or early twentieth century.

> Dahn in yond cellar it's
> Crammed full of bogs,
> They've etten mi stockens
> And part of mi clogs,
> We'll get a sharp knife and
> We'll chop their yeds off,
> An have a good supper o'
> Bog yeds an broth.

It will be productive to consider, at this point, the 'bogs' referred to in the song. The writer of the article interprets 'bogs' as 'boggards' – the same Yorkshire term for 'ghosts' – but this raises the question of why such entities would want to eat stockings or clogs. Or, for that matter, need their heads cut off, given that, as ghosts, they must already be dead.

To help explain this it should be said that the notion of ghosts as incorporeal beings is not necessarily consistent with the traditional boggard, which was often regarded as far more solid than the Dickensian spectre popularised in *A Christmas Carol* and so might well be vulnerable to the effects of decapitation.

Did You Know?

Charles Dickens visited Leeds to perform readings from some of his books at the local theatres. On his return to the capital, he described Leeds as 'an odious place'.

An early 1930s dictionary defines 'boggard' as related to the term 'hobgoblin' and again with the word 'bogle' meaning 'goblin'. This may not take us very far but we can get a greater understanding of the local meaning of the word boggard from the writings of Joseph Lawson in his descriptions of life, beliefs and customs in Pudsey in which he covers sixty years of the nineteenth century.

Lawson describes a boggard as being a fictional entity used to both entertain and intimidate through stories and threats. Akin to a more contemporary bogyman, the 'black boggard often took the form of some ugly monster or malicious ghost'. Lawson provides an illustration of the use of the term when he says, 'It was a common practice of parents when their little ones were naughty to tell them there was a black boggard up the chimney, or coming down to fetch them ... or to shut up their children in cellars and other dark places for the black boggard to take them.'

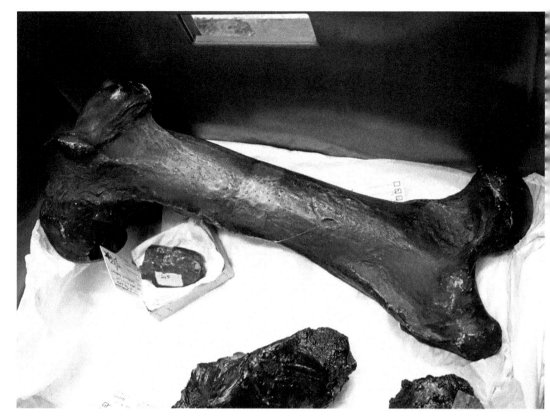

'Giants' of Armley. The bones of the Armley hippos at the Leeds Discovery Centre.

So the song is really about children testing boundaries and responding with humour to the threats adults may have used to keep them in their place – threats which may or may not have had a basis in reality.

As to whether a cryptozoologist will ever find evidence of the objective existence of boggards, it is beyond the scope of the current work to predict.

The Armley Giants
Ralph Thoresby, the first historian of Leeds, wrote of a site called Giant's Hill in Armley, which he thought to be an old Danish hill fort dating from Viking times.

The legend that came down with it was that the mound was the result of an ill-placed shot made by an angry titan, which saw a great boulder cast from the hill into Burley Lane – the evidence for which was apparently a set of cyclopean fingermarks on the stone. Of course, such tales abound in the folklore of earthworks from Cornwall to Caithness.

Another potent source for tales of giants is the discovery of large and ancient bones – usually proving to be the remains of prehistoric creatures. This is a real possibility in Armley because it was here that the remains of a family group of hippopotami were found. Some of these can be found in Leeds Museum, with the remainder stored in the Discovery Centre for safe keeping.

Above: Monstrous hounds, a feature of the old Church Institute.

Right: A somewhat more benign canine represented in Leeds sculpture.

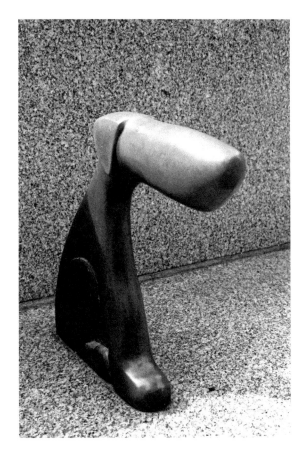

Deathless Hounds and Beasts of the Moors

There is a growing discipline within the mind sciences that suggests far from being a *tabula rasa* or blank slate, the human brain is pre-populated with friends and foes that date back to our earliest evolution. The commonplace but irrational fear of spiders and snakes, which are generally harmless in these isles, may be the consequence of images deeply buried in the human mind of far more deadly things that it was once wise to avoid. Much the same as many birds, beasts and even insects can accurately identify sometimes quite complex shapes as food or threats whether or not they have encountered them before.

Perhaps among this bestiary of hard-wired horrors lurks some of the wolf-like creatures that our ancestors faced in the dawn of our era. Could this explain the prevalence of the story of great and fearsome Baskervillian canines said to haunt the wild places just beyond the city limits, or have there indeed been monstrous hounds prowling the dark places and chilling the hearts of Loiners down the years.

There are certainly some fearsome hounds depicted in the architecture of the city. The former Leeds Church Institute building on Albion Place boasts a pack of ferocious dog-like grotesques and is surmounted by a spire that is rimmed with gargoyles, which could easily be hellhounds or relatives of one of Yorkshire's most notorious beasties – the barguest.

'Barguest' is a local name given to the huge dog-like creature of the dark places in Yorkshire, although other names such as 'Brag' and 'Gytrash' surface from time to time. Shaggy fur, huge white teeth and sometimes blazing eyes are recorded. In Otley, the barguest was the master of Otley Chevin – keeping night travellers away for reasons known only to itself.

Another tale told of a similar such fearful animal gives it the role of the dragon, this time guarding a chest of golden coins at Dobb Park Lodge in the Washburn Valley. This entity had the power of speech and was thus known as 'The Talking Dog'. A somewhat more benign incarnation of the barguest was found further out east in the Pontefract area and provided company, and perhaps a little protection, to those who needed it.

Lake Monsters and Things that Swim

Lake monsters remain the classic cryptids; the sense that in the dark depths of some loch or mere there are stranger things than fish and older things than man. Some have devoted their spare time, their careers and in some cases most of their lives to the business of trying to prove or disprove the existence of Nessie, the Ogopogo or the Mugwump.

Urban lake monsters, although reputed to exist, are rarer still. Among the many rivers, streams, canals and lakes of Leeds is it possible that something is lurking – perhaps glimpsed by anglers or the occasional late-night reveller making their way home in the half-light along a towpath or riverbank.

Besides having miles of running water and many more miles of canal, Leeds is blessed with several significant bodies of water. Progressing clockwise from the north, these include Eccup Reservoir, the lake at Roundhay, and the great ponds of Thwaite. Another artificial body of water to the south-west is Tong Road Reservoir, which is home to ducks, geese, swans, moorhens and other water fowl. Again, this is man-made but it has the benefit of several small and inaccessible islands, which happily provide the local birdlife

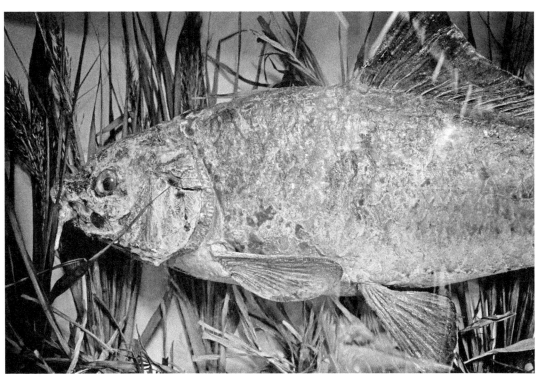

Monsters of the Tarn. This carp is kept safely behind glass at the Leeds Discovery Centre.

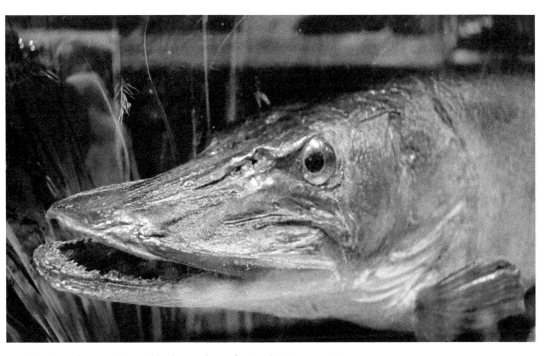

Boatmen beware! A cruel-looking pike at the Leeds Discovery Centre.

Monster from the deep. The lamprey set to make a return to Leeds.

with the privacy necessary to raise their young in safety. Further west, Rodley Nature Reserve is blessed with several large ponds teeming with life. Indeed, local schools bring their pupils here to enjoy pond-dipping for tadpoles and sticklebacks. There have not as yet been any reports of lake monsters, however.

To the north-west is Yeadon Tarn, also known as Yeadon Dam. Now, for the cryptozoologist, this body of water is far more promising. For one thing, it is far older than any of the other lakes and large ponds found in the city and the surrounding area. Also, it covers over 25 acres and has some deep areas (although prone to silt accumulation). However, if it does harbor anything truly abominable it must be a true survivor, for the tarn was reportedly drained during the Second World War to prevent German bombers using it to identify the nearby Avro factory. This doesn't, however, prevent anglers from regularly claiming to have seen monster carp at large in the lake.

Of all the possible horrors of Leeds' lakes, the one that you are most likely to encounter is the pike. This may seem like just another fish, but as the specimen pictured here shows, this really is a monster from the depths. With crocodilian eyes and a jaw full of needle-sharp, backwards-pointing teeth, the pike is the shark of Britain's waterways and can be found throughout the Leeds canal and river network. Powerfully muscled and fearless, pike are capable of leaping clear of the water in pursuit of prey.

Simon Tipple, skipper of one of Leeds' water taxis, which ply their trade around the city's waterways, describes a close encounter with a pike: 'I was on the deck of the boat, having a slurp of my energy drink when suddenly this thing flies clean out of the water right at me and lands at my feet. Then I looked and saw it was a pike about three feet long.' Understandably, Simon was taken aback, but has since tried to make sense of the event. 'I don't know what caused it to jump out like that – unless pike like the smell of Red Bull.'

Although this still may not quite class as a true monster, it is worth noting that in summer 2015 a strange rotting carcass was found washed up on the shores of Hollingworth Lake – one of the reservoirs from which the Aire and Calder Navigation gets its water supply. Horrified locals described something 5 feet in length with savage teeth, gaping jaws and baleful eyes. On examination, photos of 'The Roch Ness Monster' suggest that

this was an enormous pike that had finally come to grief. The thought that something of this ilk might be at large in the Leeds canal network should be enough to make you think twice about dabbling your feet in the water on a hot day.

Another strange aquatic beast making a return to Yorkshire after a lengthy absence is truly a prehistoric monster: the lamprey – a scaleless, eel-shaped, parasitic fish with a large sucker-mouth ringed with seemingly endless teeth.

Lampreys have been around since the time of the dinosaurs and were once a common dish throughout the British Isles, but pollution and the construction of weirs have kept them at bay. Now, with improvements in water quality and introduction of 'salmon passports', which allow sea fish to travel inland to spawn, these bizarre specimens look set to become a common phenomenon in Leeds' lakes and waterways.

The Presence at Sheepscar Tannery

In the early years of the nineteenth century, the Meanwood Valley of Leeds was home to numerous tanneries that all benefitted from the soft water of the Meanwood Beck. One such tannery was housed in premises in Sheepscar and belonged to Wilson and Walker, who founded it in 1823.

Years later, one Charles F. Stead, having prospered in the leather trade, bought the business and acquired the site with all its buildings. Over time, many of the tanneries of the Meanwood Valley closed down as business moved away to other parts, but Steads, which built a national and international reputation for high-end goods (especially suede), prospered and continues so to do even to this day.

Being an active site for so very long has meant that Sheepscar Tannery is rich in industrial history, with many of the older buildings having survived virtually unchanged since the days of Watson and Walker; perhaps it is simply their great age that has led to some of the experiences reported at this site. The staff who work at the tannery during the day do not appear to have reported anything particularly strange, but for many years Stead's has employed security officers to patrol the buildings, inside and out, during the hours of darkness to ensure everything is in good order.

One such guard, Mr Holliday, was a very experienced mobile patrol officer – not one given to squeamishness or flights of fancy. Some years ago he related the following account of his nightly visits to the tannery: 'I don't believe in ghosts or anything like that but Stead's is a very strange place at night. I can't say I've actually ever seen anything there but as soon as you go in it hits you. You can feel a sort of presence. It's like nowhere else at all.'

Other security officers who readily make nightly visits to sites all over West Yorkshire have confessed that they avoid touring the inside of the Sheepscar buildings, and instead restrict themselves to a peripheral patrol only in order to avoid the unsettling experiences brought on by the tannery.

Those looking for a ghostly explanation for the phenomenon might point to the fact that Charles Stead, who put so much of himself into the business over very many years, died suddenly in a motoring accident and must surely have been frustrated to have left so much undone. However, maybe like Fort we need to be ready for explanations that fall outside the conventions of everyday experience and spiritual thinking. Perhaps even

No beastie in sight. Butts Court with no sign of its curious inhabitant.

level-headed security officers have subtle sensitivities to hidden signals we don't yet fully understand.

The Beastie of Butts Court

We should not snigger when we hear the name 'Butts Court'. Especially when we learn that it is haunted by an as-yet-unidentified creature that may not be friendly.

This courtyard, off The Headrow in Leeds City Centre, is said to take its name from its use as a place of target practice for archery – as required by royal edict from Edward III, who was keen to maintain a high standard of English bowmanship. This training involved the use of targets or 'butts', whence its name came.

It was many centuries later, on Tuesday 19 April 2005, when the *Yorkshire Evening Post* reported a sighting by a Mr T. J. Roberts of a strange creature at around 3.30 p.m. a little over a week earlier:

> I was about halfway down this road and saw a man in front of me, five yards away, looking at something that appeared to be hopping across his path. I saw it at the same time and have never seen anything like it before. It did not seem to be affected by people, but just continued on its way across the road where it disappeared into a small yard. There was an electric transformer with iron gates in front of it.

This is not the first time Yorkshire has seen unexpected rodents in its city centres. For a time, rumours of enormous rats circulated in Bradford, but the evidence was not forthcoming. Some specialists have pointed out that a few specimens of the giant rodents

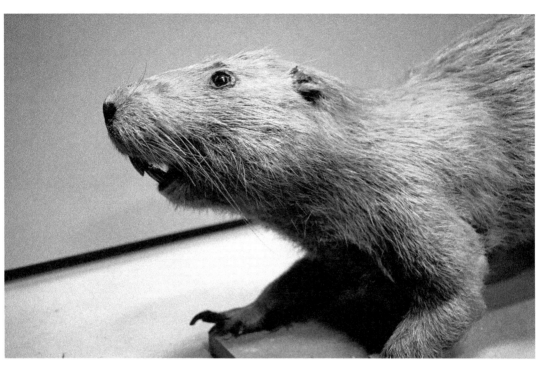

Is the beastie an escaped coypu? This specimen is kept in the Leeds Discovery Centre.

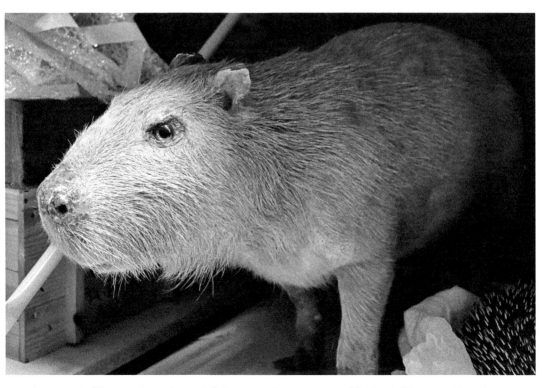

An angry looking capybara, the world's largest rodent (courtesy of the Leeds Discovery Centre).

known as coypus are at large in Britain and could account for some sightings.

Mr Roberts goes on to say,

> I could see through the bars and the man walking ahead of me just watched the beast
> go inside. He did not say anything and went on his way. I looked, hoping to catch sight
> of the creature again but it had gone. On inspecting the ground I noticed a heap of sand
> in front of the unit. There was a hole going right through it. Also there are a number of
> holes in the ground where it could have gone to. I still cannot believe what I saw. It was
> larger than a rat, with whiskers, big round ears, front legs just like a squirrel. Its back
> legs were muscular with a light fawn glossy coat and a thin tail.

Those in the know have speculated that the creature sounds like a degu: a squirrel-like
South American rodent often kept as a pet, which are sometimes known to exhaust the
interest of their owners, who might just be tempted to release them into the wild. Could
this explain Mr Robert's encounter? It seems possible, although degus are seldom as big

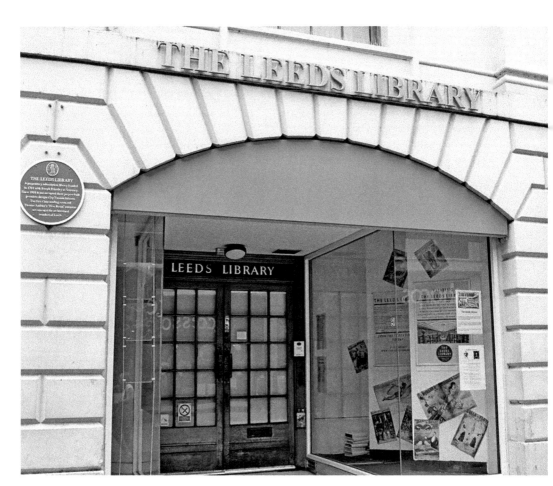

The original Leeds Library.

as a rat – certainly no bigger. Perhaps the coypu is a better explanation. It might stretch things a little far to point the finger at another South American creature, the capybara, which ranks as the world's largest rodent. One would probably find it even more difficult than the other suggestions to hide in the streets of Leeds, although one is known to lurk in the Leeds Discovery Centre, as shown here.

The Strange Goings-on in the Leeds Library

Maybe age is not a prerequisite for tales of hauntings, but the Leeds Library certainly has an advantage; having been founded in 1768, it is the oldest organisation of its kind. Just to be clear, this is not the city library next to the town hall but rather a more discreet sort of building on Commercial Street. It is run as a charity and is a membership organisation. A long time before the concept of the haunted library reached the silver screen in the film *Ghostbusters*, the Leeds Library became known as the home of the ghost of at least one former librarian – Mr Thomas Sternberg. Mr Sternberg's appointment commenced in 1857 and ended with his death in 1879.

The tale is told of how his immediate successor, one John MacAlister of Harrogate, was alone in his office at the library one evening after dark. Keen not to miss the last train home, MacAlister took up his lamp to enter the main room and saw across the gloom what looked like a man's face. Knowing himself to be alone in the building, MacAlister assumed there was a burglar so he returned to his office, where he kept a revolver.

With a little more confidence, he returned to the central chamber and cautiously began to seek out the felon. He padded past several rows of shelves before spotting a face peering around the end of a row. It had an odd appearance, as if the head was protruding from a body that was inside the bookcase. The skin was pallid and there was no hair on the head, which had eyes set very deeply in its skull.

MacAlister watched as the figure extricated itself from the bookshelf and made for the lavatory, into which it disappeared. Still believing it to be some sort of intruder, when MacAlister reached the lavatory and looked inside he was alarmed to find neither trace of his quarry, nor any potential exits. This was enough to make him drop his pretence of being a hero. He rushed out of the building and raced for his train – only to find he'd missed it.

The following morning, he relayed the tale to a member of the library committee, who recognised MacAlister's description as matching that of the former librarian.

Since that time, several sightings have been made and the site has gained a reputation for ghostly goings-on. This has even attracted local writer Jeremy Dyson, known for his role in creating the macabre *League of Gentlemen* and for his interest in ghost stories. Dyson used the library to create some interesting film footage, which is available online for those not of a faint heart.

Ghosts of the City Varieties

It would be difficult to properly do justice to the number of ghost stories attached to this well-loved entertainment venue. It originated as an adjunct to the White Swan public house but has outgrown its origins many times over to become a jewel in the city's crown.

Its first recognisable outing would be as 'Thornton's New Music Hall and Fashionable Lounge' in 1865, but it went through several makeovers and changes of name before it became the venue we know today.

The building itself is unusual and has had walls, doors and even whole rooms moved around – sometimes sealing off places that were once accessible – with rumours of hidden walkways that extend from its cramped cellars deep under the city.

There are tales told of a phantom pianist – sadly anonymous – and a female vocalist, although again her identity is not clear.

Another account tells of a visiting television producer, Len Marten, who was accidentally locked in the theatre bar after hours. Not wanting to make a name as someone who made a fuss, Marten settled down for the night. However, he relates that during the night he awoke to the feeling of terrible cold, accompanied by the apparition of a woman in a crinoline dress who remained until he managed a cry, which seemed to drive her away, at which point the room became warm again.

These are just two of the many spectral tales told of the City Varieties; more are collected in Ken Gore's excellent *Haunted Leeds*, where he recounts over a dozen such episodes all taking place in the venerable venue.

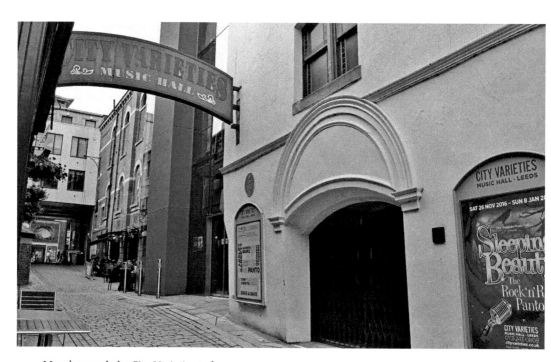

Most haunted, the City Varieties today.

Bibliography

Books

Allen, Karen, 'The History of Hallowe'en and Related Festivals in Leeds and its District' (University of Bristol: PhD Thesis, 2012).

Alexander, Christine; Sellars, Jane, *The Art of the Brontës* (Cambridge University Press: 1995).

Barker, Juliet, *The Brontës* (Weidenfeld and Nicolson: 1994).

Booth, Jean (Compiler), *Childhood Memories in Woodhouse* (Woodhouse Local History Group: Leeds, 1993).

Carpenter, Humphrey, *Tolkien: A Biography* (Ballantine Books: New York, 1977).

Carpenter, Humphrey; Tolkien, Christopher, eds., *The Letters of J. R. R. Tolkien* (George Allen & Unwin: London, 1981).

Cunniff, Tom, *The Supernatural in Yorkshire* (Dalesman: Lancashire, 1985).

Donnelly, James, 'Brotherton, Edward Allen, Baron Brotherton (1856–1930)', *Oxford Dictionary of National Biography* (Oxford University Press: 2004).

Fraser, Rebecca, *Charlotte Brontë: A Writer's Life* (2 ed.) (Pegasus Books LLC: New York, 2008).

Fort, Charles H., *The Book of the Damned* (John Brown Publishing: London, 1919).

Goor, K., *Haunted Leeds* (Tempus: 2006).

Harman, Claire, *Charlotte Brontë: A Life* (Penguin Books: 2016).

Jenkins, H., *The Life of George Barrow* (London: 1924).

Opie, Iona & Peter, *The Lore and Language of Schoolchildren* (Paladin: St Albans, 1977).

Scott, Harry J., *Yorkshire Tales and Legends* (Dalesman Publishing: Lancaster, 1990).

Stevenson Tate, Lynne (ed.), *Aspects of Leeds Volume 1* (Wharncliffe Publishing: Barnsley, 1998).

Stevenson Tate, Lynne (ed.), *Aspects of Leeds Volume 2* (Wharncliffe Publishing: Barnsley, 1998).

Sumner, A., *Mitzi Cunliffe* (University of Leeds: 2016).

Thornton, David, *Great Leeds Stories* (Fort Publishing: 2005).

Waddington-Feather, John, *Leeds: The Heart of Yorkshire* (Basil Jackson Publications: Leeds, 1967).

Westwood, J.; Simpson J., *The Lore of the Land - A Guide to England's Legends from Spring-Heeled Jack to the Witches of Warboys* (Penguin: London, 2005).

Whitaker, Terence W., *North Country Ghosts & Legends* (Grafton Books: London, 1988).

[Author Unknown] *Katherine Earle the Rothwell Witch and other stories* (Rothwell: 'The Author', 1994).

Internet

http://www.100greatblackbritons.com/bios/Pablo_Fanque.htm

https://allpoetry.com/Dorothy-Una-Ratcliffe

https://arts.leeds.ac.uk/legaciesofwar/about-us/people/peter-liddle/

http://www.bl.uk/victorian-britain/articles/victorian-prisons-and-punishments

http://blog.nationalmediamuseum.org.uk/louis-le-prince-created-the-first-ever-moving-pictures/

https://www.britannica.com/biography/Ivan-Bunin

http://www.encyclopediaofarkansas.net/encyclopedia/entry-detail.aspx?entryID=1702

https://www.iconinc.co.uk/blog/interesting-facts-about-leeds/

http://www.independent.co.uk/arts-entertainment/films/reviews/the-first-film-film-review-the-mysterious-disappearance-of-inventor-louis-le-prince-10362358.html

http://leeds-list.com/out-and-about/locked-in-time-the-centenary-bridge-love-locks/

http://leeds-list.com/out-and-about/the-mysterious-world-beneath-ground-level/

http://www.leedsmuseum.co.uk/tour/index_4.shtml

https://library.leeds.ac.uk/art-gallery

https://library.leeds.ac.uk/special-collections

https://library.leeds.ac.uk/special-collections-online-exhibitions

https://library.leeds.ac.uk/info/246/benefaction/78/benefactors/1

http://logicmgmt.com/1876/overview/victorian_woman/victorian_woman_education.htm

https://lovelockdiaries.wordpress.com/2015/04/23/love-locks-in-leeds/

http://www.nationalarchives.gov.uk/education/resources/victorian-prison/

https://www.nobelprize.org/nobel_prizes/literature/laureates/1933/bunin-bio.html

https://roystockdill.wordpress.com/murder-by-poisoning-and-the-yorkshire-witch/

https://shoddyexhibition.wordpress.com/2016/04/24/mitzi-cunliffe-sculptor/

http://www.tolkiensociety.org

http://vcp.e2bn.org/teachers/11416-what-was-it-like-to-be-a-prisoner-in-a-victorian-gaol.html

https://en.wikipedia.org/wiki/Charlotte_Brontë

https://en.wikipedia.org/wiki/George_Borrow

https://en.wikipedia.org/wiki/Ivan_Bunin

https://en.wikipedia.org/wiki/Leonid_Andreyev

https://en.wikipedia.org/wiki/Mitzi_Cunliffe

https://en.wikipedia.org/wiki/Owney_Madden

https://en.wikipedia.org/wiki/Pablo_Fanque

https://en.wikipedia.org/wiki/Peter_Liddle

https://en.wikipedia.org/wiki/Yury_Lomonosov

http://www.yorkshirepost.co.uk/news/how-the-black-prince-charged-into-leeds-1-6560789